Sagamore Hill

Sagamore Hill

THEODORE ROOSEVELT'S
SUMMER WHITE HOUSE

BILL BLEYER

THE
History
PRESS

Published by The History Press
Charleston, SC
www.historypress.net

Cover image by Audrey C. Tiernan.

First published 2016

Manufactured in the United States

ISBN 978.1.46711.809.5

Library of Congress Control Number: 2016936700

To my parents, Milton and Adele Bleyer, and sister and biggest booster, Joan Bleyer Lazarus, for their early and continual support of my obsession with history

Contents

Acknowledgements

* My helpful editors at The History Press: Whitney Landis, Stevie Edwards, Amanda Irle and Abigail Fleming.
* Superintendent Kelly Fuhrmann of Sagamore Hill National Historic Site and Tweed Roosevelt of the Theodore Roosevelt Association for facilitation and support.
* For help with research and historical images: Susan Sarna, Elizabeth DeMaria, Laura Cinturati, Amy Verone and Marc Wasser of Sagamore Hill National Historic Site; Heather Cole of the Houghton Library at Harvard University; Oyster Bay town historian John Hammond; and Elizabeth Roosevelt, Philip Blocklyn and Nicole Menchise of the Oyster Bay Historical Society.
* For new photographs: Audrey C. Tiernan, Xiomáro and Robert A. DiGiacomo.
* Ron Fleming for putting me up in Cambridge.
* And my advance readers for selected chapters: John Hammond, Elizabeth Roosevelt and Tweed Roosevelt. And those who proofread every word: Joe Catalano, Laura Cinturati, Elizabeth DeMaria, Harrison Hunt, Amy Verone and, most of all, Susan Sarna for her meticulous fact-checking and enthusiastic encouragement.

Introduction

Hours before he died at his Long Island home in the winter of 1919, Theodore Roosevelt is said to have turned to his wife and asked: "I wonder if you know how I love Sagamore Hill."

His spouse, Edith Kermit Roosevelt, and his six children shared that love of the hilltop house and the homestead of the same name in Cove Neck on Long Island. The tens of thousands who have visited the property since it was opened to the public in 1953 have loved it as well. TR's house is more than just an attractive structure; it is one of the best examples of a home of a famous person that vividly illustrates the multifaceted personality of its owner. Sagamore Hill is solidly substantial but unpretentious. It overflows with objects that reflect the limitless energy and varied interests of the twenty-sixth president and all of his roles: politician and statesman, historian, soldier, hunter, conservationist, prolific author and family man. Its cozy dining room, many bedrooms and comfortable communal spaces are evidence of the importance of family as the center of Roosevelt's sprawling universe and the need of the gregarious and insatiably curious host to surround himself with interesting guests.

For most of my life, I have been one of those admirers of TR and his Sagamore. As a young boy growing up on Long Island, my parents took me to see the property and learn about the Renaissance man who owned it. The three-story, twenty-eight-room Queen Anne structure with its prominent gables, dormers, verandas and massive brick chimneys was certainly impressive. But I was even more enthralled with the animal trophies in the

front hall and the North Room, its entrance flanked by elephant tusks. While I had no interest in ever going big-game hunting, as someone who loved books I felt a kinship with the owner of the volumes filling the shelves of the library and the Gun Room. And I was fascinated by the strange appearance of the old-fashioned claw-footed bathtub in the second-floor bathroom.

Subsequently, I have visited Sagamore Hill National Historic Site dozens of times, mostly covering stories for the Long Island daily newspaper *Newsday* over three decades and more recently to research this book. But I have never lost that initial sense of wonder every time I walk under the porte-cochère, cross the piazza and reenter the world of Theodore Roosevelt.

The house has been a National Historic Site since 1963 and was added to the National Register of Historic Places in 1966. Recently fully restored from foundation to roof, the 14,175-square-foot structure encourages time travel back to the era of Roosevelt's presidency in the early 1900s. TR's family is the only one to have ever lived there—for sixty-four years. About 90 percent of the contents on the first two floors are original. Some of the twelve buildings, such as the farm shed and chicken house, that stood during Roosevelt's time are still there, if repurposed.[1]

Hundreds of books have been written about Theodore Roosevelt, his family and their Long Island home. But all but one have focused primarily on the Roosevelts with Sagamore Hill as a part-time setting for their fascinating lives. That one exception is *The Roosevelt Family of Sagamore Hill*, written by Hermann Hagedorn, executive director of the Theodore Roosevelt Association, and published in 1954. It is a wonderful read, and many of its anecdotes are retold in this book. But Hagedorn's account is incomplete because it ends with TR's death.

This book tells the full story of Sagamore Hill, starting with Theodore's grandfather discovering Oyster Bay as the perfect getaway from hot and unhealthy summers in New York City. It covers TR's decision to buy property nearby to build a home named Leeholm for his beloved first wife, Alice Lee. It picks up the story when Roosevelt returned to Oyster Bay after his Dakotas ranching sojourn following the death of his wife and mother on the same day. It recounts how TR's second wife, Edith, made the house built for another woman a home for herself and a growing rambunctious family. TR used Sagamore Hill as both a working farm and his political headquarters in his early days in government and then as the Summer White House. His widow kept the house and property almost unchanged until it was sold to the Theodore Roosevelt Association after her death. And finally, this work covers how the National Park Service assumed the legacy

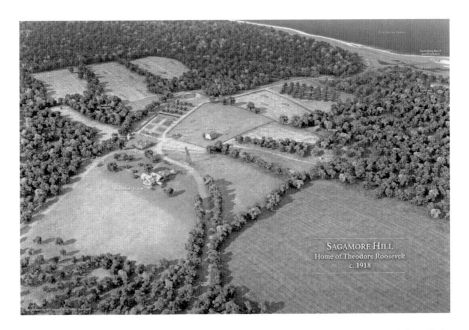

A computer-generated bird's-eye view of Sagamore Hill in 1918. *Courtesy of the National Park Service, Harpers Ferry Center.*

in 1963. Over the years, the agency has returned the house and grounds to a more historic appearance and finally closed what it had begun to call the Theodore Roosevelt Home—to distinguish it from the homestead—for three years for a major restoration. The $10 million project re-created the original light and air shaft running through the center of the house and a back porch—historical features removed in early renovations when the house became a public museum. And it improved lighting to enhance the visitor experience.

The book includes many previously unpublished photographs of the house and grounds along with a center insert guide to them.

My hope is that this book will help readers understand why TR could write the following to his daughter Ethel in 1906: "Fond as I am of the White House and much tho I have appreciated these years in it, there isn't any place in the world like home—like Sagamore Hill, where things are our own, with our own associations, and where it is real country."[2]

1
The Roosevelts Come to Oyster Bay

Theodore Roosevelt was not the first member of his distinguished New York City family to discover the attractions of water and woods in Oyster Bay. That distinction belongs to his grandfather Cornelius Van Schaack Roosevelt, a successful businessman who served as a director of the Chemical Bank of New York. He rented a summer home in the sleepy waterfront community settled by the English in 1653 about twenty-eight miles east of Manhattan and named after the adjacent bountiful body of water.[3]

It was sometime around the Civil War. But "we don't know when they first came," said Elizabeth Roosevelt of Cove Neck, whose great-grandfather and TR's father were brothers. The first documentation of the family's presence is a logbook from the *D.R. Martin*, a side-wheel steamboat that served Oyster Bay, in the collection of the Oyster Bay Historical Society, according to Oyster Bay town historian John Hammond, who has been researching the history of Cove Neck with Elizabeth Roosevelt. A logbook entry on September 27, 1867, shows the vessel transported a wheelchair, commode, piano and camp stool owned by Silas Weir Roosevelt, the eldest son of Cornelius Van Schaack, to Long Island.

Theodore Roosevelt was born on October 27, 1858, one of four children of Theodore Roosevelt Sr., a well-to-do merchant and philanthropist, and his wife, Martha Bulloch Roosevelt, in the family's Manhattan brownstone at 28 East Twentieth Street. (Demolished in 1916,

it was re-created in 1923 by the Theodore Roosevelt Memorial Association and is now Theodore Roosevelt Birthplace National Historic Site.) Teedie, as he was nicknamed, was a sickly child. When he had an asthma attack, often in the middle of the night, his father would rush him to various places in the countryside, including Oyster Bay, to recover. His mother, nicknamed Mittie, wrote to her daughter Anna, nicknamed Bamie, on August 10, 1870: "Teedie had an attack of asthma on last Saturday night and Papa took him to Oyster Bay where he passed Monday night and Tuesday night. Of course, Teedie was in ecstasies of delight."[4]

After Cornelius Van Schaack Roosevelt died in Oyster Bay in 1871, his son Silas Weir is believed to have continued coming to Oyster Bay. Another son, James A., is known to have maintained the tradition of renting or "hiring" a summer home in Oyster Bay. It was the house of Richard Irvin on the western edge of what is now the Village of Oyster Bay Cove, just east of the Oyster Bay business district.[5]

And in 1874, James's brother Theodore Roosevelt Sr., whose family is believed to have stayed with Cornelius Van Schaack prior to his death, began renting in Oyster Bay to be close to relatives. TR was fifteen when his

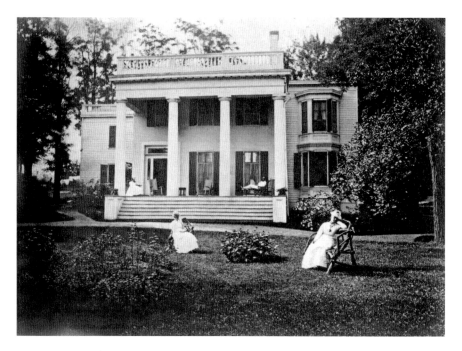

Tranquility, the house in Oyster Bay rented by his father when Theodore Roosevelt was a boy. *Houghton Library, Harvard University MS Am 1785.8 (580).*

parents first transported the family to Long Island after spending summers in New Jersey and along the Hudson River. They spent nearly four months at a house known as Tranquility on Cove Road in Oyster Bay Cove just east of where Oyster Bay High School is now located. It featured tall white columns and wide verandas, elements that should have made TR's mother feel at home, having grown up in Georgia in a mansion of similar architectural style. Tranquility was owned by Smith Thompson Van Buren, a son of President Martin Van Buren. So, in an interesting piece of political trivia, the father of the twenty-sixth president rented from the son of the eighth president.[6]

Theodore Sr. joined other Roosevelts as a member of Seawanhaka Yacht Club of Oyster Bay, Long Island's oldest, founded in 1871. He rented Tranquility (sometimes spelled Tranquillity) for four summers. After he died in February 1878, the family continued to come to Oyster Bay. But that summer, TR apparently could not bear to be at Tranquility without his father there and vacationed in Maine instead. (The house was demolished around 1948.)[7]

As he had as a small child, the teenaged Theodore Roosevelt loved Oyster Bay and thrived there. The daily routine was a horseback ride led by his father and afternoons on the water in rowboats or a sailboat and visits to the other Roosevelt houses and exploration of the nearby countryside. Theodore Sr. also had the children put on theatrical productions.[8]

TR wrote later:

> *In the country we children ran barefoot much of the time, the seasons went by in a round of uninterrupted and enthralling pleasures—supervising the haying and the harvesting, picking apples, hunting frogs successfully and woodchucks unsuccessfully, gathering hickory-nuts and chestnuts for sale to patient parents, building wigwams in the woods, and sometimes playing Indians in too realistic manner by staining ourselves (and incidentally our clothes) in liberal fashion with poke-cherry juice.*[9]

TR's diary and letters from around 1870 are filled with references to spotting and shooting birds and also rowing on Cold Spring Harbor and Long Island Sound. He continued to spend his summer vacations in Oyster Bay even while a student at Harvard. He compiled *Notes on Some of the Birds of Oyster Bay*, published in 1879, while on Long Island.[10]

These activities of his childhood—the exploration of forested hills on foot or horseback and waterways and shorelines by rowboat and shooting

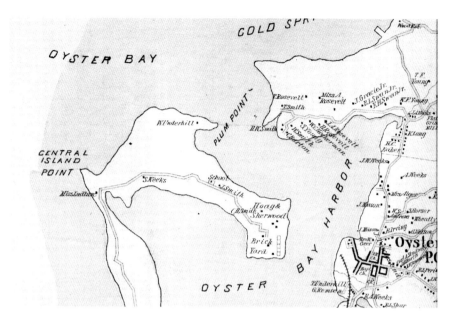

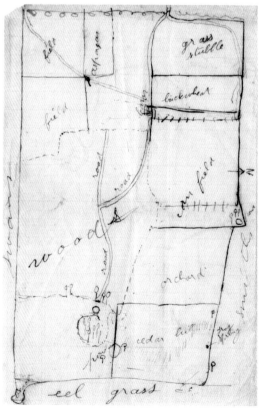

Above: Map of Cove Neck from the *Atlas of Queens County 1891* showing the peninsula after Theodore Roosevelt and relatives had purchased property there. *Courtesy of the Oyster Bay Historical Society.*

Left: Theodore Roosevelt made this drawing of the property at Sagamore Hill to show relatives in 1883 or 1884. *Courtesy of the National Park Service, Sagamore Hill National Historic Site.*

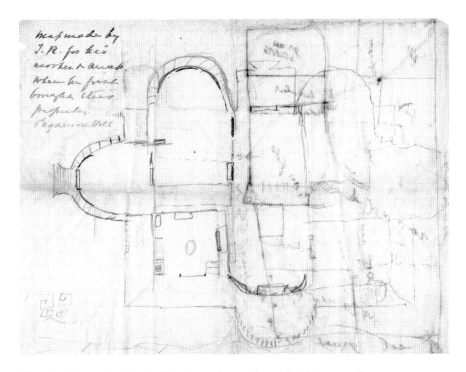

Theodore Roosevelt's sketch of the layout he envisioned for his home at Sagamore Hill. *Courtesy of the National Park Service, Sagamore Hill National Historic Site.*

specimens for his own taxidermy museum—would continue through his adult years at Sagamore Hill.

Roosevelts had been renting in Oyster Bay for two decades before any of them bought property there. On November 19, 1880, James A. Roosevelt, great-grandfather of Elizabeth—the last Roosevelt living in Oyster Bay—bought eighty acres in Cove Neck from Daniel Kelsey Youngs for $250 an acre. His house, known as Yellowbanks, was completed the next year. It still stands on property adjoining Sagamore Hill on Cove Neck Road but is no longer owned by a Roosevelt. TR's cousin Dr. James West Roosevelt purchased four acres along Oyster Bay Harbor adjacent to Yellowbanks and built a home he called Waldeck. Another cousin, William Emlen Roosevelt, son of James A., owned seventy-nine acres that fronted on Cold Spring Harbor north of what would become Sagamore Hill.[11]

For Theodore Roosevelt, 1880 was a momentous year. He graduated from Harvard and married Alice Hathaway Lee of Chestnut Hill, Massachusetts, the cousin of a classmate he had met in his junior year.

The wedding was held in Brookline, Massachusetts, near her home, on October 27, which was also TR's twenty-second birthday. The newlyweds spent their two-week honeymoon at Tranquility and soon purchased property nearby for themselves and the large family he envisioned.

2
Building Leeholm

Not long after arriving in Oyster Bay for the honeymoon, Theodore took his new bride to the nearby Cove Neck peninsula. He showed her land near the tract owned by his uncle James that he had often explored in past summers and thought might make a suitable homestead for the couple. The site previously had been used by Native Americans from the Matinecock branch of the Algonquin tribe until their leader, Sagamore Mohannis, signed away their rights to settlers of European descent in the seventeenth century.[12]

After their Oyster Bay sojourn, Theodore and Alice moved into a house next door to his sister Corinne Robinson on West Forty-Fifth Street in Manhattan while they planned a move to the country. The couple looked at property upstate in the Mohawk Valley sulfur springs spa community of Richfield Springs, but TR did not like the people there and felt it was too far from New York City.[13]

So Roosevelt decided to purchase the land he had shown Alice on Long Island. The property, the highest point on Cove Neck and almost three miles east of the hamlet of Oyster Bay, was owned by Thomas Youngs. TR arranged to buy 155 acres stretching from near the Oyster Bay Harbor shoreline on the west to Cold Spring Harbor on the east and abutting property owned by relatives. The hilltop, bare then but now surrounded by mature trees, provided a view of both harbors and Long Island Sound to the north. TR paid $10,000 in cash with a mortgage for $20,000 for the property as well as the crops in the fields and stored in the barn, the only structure on the land.[14]

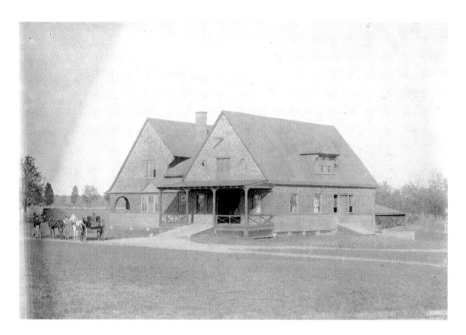

The Stable and Lodge, the first structure built by Theodore Roosevelt at Sagamore Hill. *Courtesy of the National Park Service, Sagamore Hill National Historic Site.*

The Old Barn was wood framed with vertical siding and large hinged doors on the side in the style of English barns. The building was located on the southern boundary about four hundred feet southeast of where the main house would be constructed on a wheat field at the highest point of the tract, 168 feet above sea level.[15]

Youngs and three relatives conveyed the property in three deeds dated from November 22, 1880, to August 22, 1883.[16] The new Roosevelt homestead included eight hundred feet of Cold Spring Harbor beachfront, split by tidal Eel Creek, which was crossed by a wooden bridge. There were also two ponds. One was near the beach and the other in the center of the northern section. The pond by the beach, known as Lower Lake, would become a favorite of the Roosevelt children, as turtles were frequently seen there. There was a glacial kettle hole north of the house called the Devils Punch Bowl. The Roosevelts used the thirty-foot depression as a ski slope. The property sloped steeply on the southwest and eastern sides. Automobiles had a difficult time traversing the 35 percent southwestern grade in the early 1900s.[17]

Because of the home's eminence and its history, TR would ultimately name his domain for the Matinecock leader. "Sagamore Hill takes its name

from the old Sagamore Mohannis, who, as chief of his little tribe, signed away his rights to the land two centuries and a half ago," he wrote in a 1913 magazine article.[18]

Cove Neck, now a village of spacious homes on large lots, was sparsely populated at the time. An 1873 map depicts fewer than a dozen houses. After buying the 155 acres, Theodore and Alice took no immediate action to increase the population. TR had a lot going on in Manhattan. In 1881, he was elected—at age twenty-three—to the New York State Assembly. He was reelected in 1882 and 1883. And he was more than a rising political figure. In 1882, *The Naval History of the War of 1812*, the first of his more than three dozen books, was published.[19]

Still, Theodore and Alice continued to plan a Cove Neck home, which TR intended to call Leeholm for his beloved wife. The New York City architectural firm of Lamb and Rich was hired to design a stable-lodge, which would house livestock and farmworkers, and later the family residence. Hugo Lamb and Charles A. Rich had helped develop country suburbs such as Short Hills, New Jersey, in the early 1870s and were known for their use of Queen Anne– and Shingle-style designs popular in the mid-Atlantic and New England states. The couple walked the property with the architects and relatives to fine tune their ideas. The archives at Sagamore Hill contain a two-sided pencil sketch on slightly yellowed lined paper showing TR's concept for the house on one side and the layout of farmland and woods on the other. A note written on it by his second wife, Edith Kermit Carow Roosevelt, describes it as a "map made by T.R. for his mother & aunt when he first bought this property. Sagamore Hill." The house sketch depicts a wraparound porch and layout eventually built after Lamb and Rich fleshed out the concept.[20]

The drawing of the property shows eelgrass on the shore of Cold Spring Harbor. A cedar-covered hill leads up to an orchard. Woods are marked to the south of the orchard, a cornfield to the west and buckwheat and grass stubble near the northwestern boundary of the property. The central western portion is marked as an asparagus field while the southwest corner is marked as fields.

On October 20, 1883, Roosevelt signed a contract with John A. Wood & Son of Lawrence, Long Island, to build the Stable and Lodge by the following February 1 for $5,160. It was situated several hundred feet northeast of where the house would be built. The shingle-sided L-shaped Stable and Lodge faced west and was approximately sixty-five feet by seventy-five feet. One side provided shelter for cows and horses as well as storage for hay and

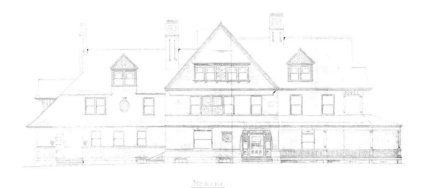

The architects' 1883 plans for the north side of the house. *Courtesy of the National Park Service, Sagamore Hill National Historic Site.*

grain. The other side became the home of caretaker Noah Seaman. (The structure was destroyed by fire in 1947.)[21]

As for the design of the main house, TR had a strong sense of what he wanted, at least for the interior. He recalled in a letter to a magazine editor more than three decades later:

> *My means were strictly limited, and I didn't know enough to be sure what I wished in outside matters. But I had a perfectly definite views what I wished in inside matters. . . . I wished a big piazza, very broad at the n.w. corner where we could sit in rocking chairs and look at the sunset; a library with a shallow bay window opening south; the parlor or drawing room occupying all the west end of the lower floor; as broad a hall as our space would permit; big fireplaces for logs; on the top floor the Gun Room occupying the western end so that north and west it looks over the sound and bay.[22]*

But in 1884, before he could build his house with the big piazza, Theodore Roosevelt's promising and comfortable life was upended. Initially, the future was bright: Alice gave birth to their first child, a daughter named for her, on February 12 while TR was in Albany for the assembly session. Two days later, he suffered the greatest loss of his life: his wife and mother died at Mittie's house on West Fifty-Seventh Street on the same day—Valentine's Day. His mother succumbed at 3:00 a.m. from

Artist's 1883 rendering of the north side of the house. *Courtesy of the National Park Service, Sagamore Hill National Historic Site.*

typhoid fever. Alice was the victim of kidney inflammation from Bright's disease eleven hours later. In his diary, Roosevelt wrote only eight words: "The light has gone out of my life."[23]

Surprisingly, despite the "black care" of depression that enveloped him, only two weeks later Roosevelt moved ahead with construction of the house in Cove Neck. At the urging of Bamie, TR concluded that he still needed a permanent home for his daughter, who had been placed temporarily with his sister in Manhattan. He signed an agreement on March 1, 1884, with John A. Wood & Son to build the house designed by Lamb and Rich for $16,975. Construction commenced in May.[24]

The amount was modest in an era when the median cost of a country house was between $20,000 and $30,000. Many of Roosevelt's future Long Island neighbors owned homes in New York City and only summered in Oyster Bay. But since he could not afford that, he had Sagamore Hill built as a year-round residence with two hot-air furnaces and ten fireplaces, which turned out to be inadequate. TR built as the North Shore was beginning to evolve into the Gold Coast—the summer home location for newly minted millionaires like the Vanderbilts rather than old-money families like the Roosevelts. Unlike the large surrounding estates, Sagamore Hill was not laid out by a landscape architect and did not have classical formal gardens or a large farm complex. For the size of the property, however, Sagamore's farming operation was fairly substantial: half of the acreage was either planted with wheat, rye or corn or used as several large pastures while the gardens occupied another three acres.

Most other estates featured mansions with more rooms than the twenty-seven at Sagamore. And there were about nine servants in the first two decades of the twentieth century and later only four in 1930, whereas the usual number ranged from twenty to fifty on a one-hundred-acre estate. Even small homes usually had ten to fifteen staff members.[25]

While the house may have been modest by Gold Coast standards, Lamb and Rich designed it to last. The stone foundation was twenty inches thick. And the entire structure projected the strength and stability of its young owner, who was making his name in the state's tumultuous political environment. With at least fourteen bedrooms for family, guests and staff, it was clear that Roosevelt expected to head a large family.[26]

Lamb and Rich chose a first story of brick with shingles over a wood frame above that. They devised an asymmetrical floor plan with a high roof crowned by white gables in a departure from the highly structured architecture of the High Victorian period. They called for mixed materials, characteristics of the Queen Anne style. Richardsonian arches common in the Shingle style were included in the upper floors. European influences, such as terra-cotta sunflowers and imitation half-timbering, were superimposed on an American-style exterior. The house has a cruciform layout with longer west and east wings separated by shorter north and south wings. There are large central gables on the third floor on the south, west and north wings. The large piazza wraps around the west wing.[27]

Inside, the main door on the south side opens into the front hall. The library is to the right, with the dining room north of that on the other side of a hallway. The parlor, later the drawing room, is to the left of the entry door. The kitchen, pantry and laundry were on the east side of the house. The second floor was divided into family bedrooms, a nursery, guestrooms and the house's sole bathroom. The third floor had the Gun Room, family bedrooms, servants' bedrooms, storage rooms and a sewing room.[28]

Above the doorway on the west side of the house, Wood carved into the lintel the Roosevelt family motto: *Qui plantavit curabit*, "He who planted will preserve. "At different times, TR farmed between forty and ninety-five acres, so he lived up to the maxim.[29]

With the house project launched, TR dealt with his grief by throwing himself into his work. He completed his term in the legislature. Then in June, he left for the Dakota Territory, where earlier he had purchased two ranches, after delegating oversight of his daughter and construction in Cove Neck to Bamie. For two years, TR shuttled between the West and New York. He raised cattle and hunted game, including some whose heads were

shipped east to adorn the house at Sagamore Hill. He wrote to Bamie from Little Missouri, Dakota, on June 17, 1884:

> *I have never been in better health than on this trip. I am in the saddle all day long either taking part in the round up of the cattle, or else hunting antelope (I got one the other day; another good head for our famous hall at Leeholm).*[30]

In another letter to his sister from Fort McKinney, Wyoming, on September 20, 1884, he does not refer to the house as Leeholm:

> *I soon shot all the kinds of game the mountains afforded. I came out after two weeks, during which time I killed three grizzly bear, six elk (three of them have magnificent heads and will look well in the 'house on the hill'). . . . I have now a dozen good heads for the hall.*[31]

Roosevelt found emotional solace in what is now North Dakota. But he also suffered stock losses from bad weather, which almost ruined him financially.[32]

TR had promised his bride, who was accustomed to the bustle of Boston and Manhattan society, that she would have the company of his family

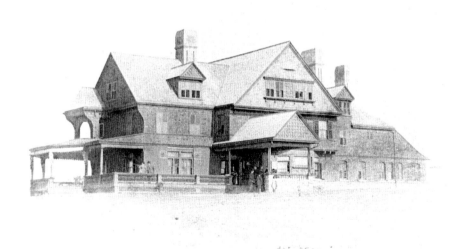

Recently completed Sagamore Hill, circa 1885. *Courtesy of the National Park Service, Sagamore Hill National Historic Site.*

members on rural Long Island. Even though Alice was gone, he took action to expand the family enclave in Cove Neck. Roosevelt, whose inheritance had made him comfortable as he came into manhood, was financially stressed early in his career and sold two parcels in December 1884. One, 28.19 acres on the southwestern part of his land, went to Bamie for $5,000. He conveyed 32.5 acres running all along the southern edge of the property to his aunt Anna Bulloch Gracie, his mother's eldest sister, for $5,000. That left him with 95.00 acres. While TR's home was being constructed, James K. Gracie had the famed firm of McKim, Mead and White design a Shingle-style house on the land his wife, Anna, had bought. They named it Gracewood.[33]

TR expanded his holding by purchasing a meadow, beach and land along Eel Creek in 1900. But he also continued to sell parcels to relatives. A six-acre field on the southwest portion of the property was transferred to his uncle James in 1894. (The next year, James purchased the twenty-eight acres TR had sold to Bamie.) TR exchanged land with his cousin Emlen in 1906 to provide a right of way for an access road. That left him with eighty-seven acres, the size of the property until Edith gave four acres to their son Ted to build his Old Orchard home in 1938. Emlen owned sixty-two acres to the northeast of Sagamore Hill and sixty-one acres to the south. His southern property included the thirty-two-acre Gracewood tract, which he acquired sometime before 1906, making him the largest landowner on Cove Neck.[34]

After the Sagamore Hill residence was completed in March 1885, an icehouse was built on the east side. The octagonal structure was used to store ice cut from nearby ponds.[35]

Sagamore Hill's first occupant was Bamie, who entertained polo players and foxhunting guests at her brother's urging while he returned to New York periodically to see his daughter and new house as well as keep up his political connections. TR was in Cove Neck from June to August 1885 to attend parties, chop wood and ride. That year, he participated in more than a half dozen foxhunts. He returned in October and invited the Meadowbrook and Essex hunts to Sagamore Hill. While chasing a fox with thirty-four other riders, TR's horse clipped the top rail of a five-foot fence and fell over on its side atop a rock pile. Roosevelt broke his arm. His face covered with blood, he remounted and continued the chase. When he got back to Sagamore, Alice was waiting at the stable with her nurse. She fled in horror from the specter of her bleeding father, and he chased her, laughing. That night he presided at a hunt ball wearing a sling.[36]

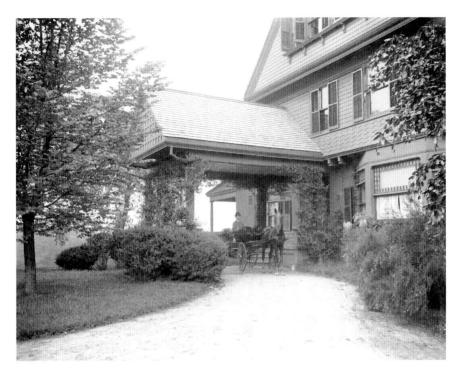

A horse-drawn cart under the porte-cochère in 1905. *Courtesy of the National Park Service, Sagamore Hill National Historic Site.*

TR and Bamie retreated to her Manhattan house on Madison Avenue rather than spend the winter in cold and drafty Sagamore Hill. But he would return east for good the following year and find a new mistress for his house on the hill.

3
A Rising Politician's Home

When Roosevelt came back to New York to visit during his two years in the Dakotas, he stayed with Bamie. But he imposed a special condition: his sister must ensure he would not run into their childhood friend Edith Kermit Carow.

Theodore and Edith had known each other since he was three and she was an infant, as her family lived next to his grandfather on Union Square. Edith had visited the Roosevelts at Tranquility when TR was seventeen and she fourteen. He spent hours rowing her around so they could talk about wildlife and books. Theodore appreciated that Edith was almost as widely read as he was. For some unknown reason, Theodore and Edith had ended their friendship. But she remained close to other members of the family and even attended Theodore and Alice's 1880 wedding. Four years later, despite TR's precautions, he and Edith encountered each other at Bamie's. They rekindled their fondness for each other and became engaged on November 17, 1885. The couple told no one, as it had been less than two years since Alice's death, and they feared the reaction of family and friends.[37]

The following summer, Roosevelt left his Badlands ranches to accept the Republican nomination to run for mayor of New York City, even though he knew he had no chance of winning in the Democratic stronghold. After being crushed at the polls, he sailed for England and married Edith in London on December 2, 1886. The couple honeymooned for fifteen weeks in England and on the Continent. In Florence, Italy, they bought furniture for the dining room at Sagamore Hill before learning that the worst winter

in the Dakotas in half a century had almost wiped out most of TR's cattle herd and one-third of his inheritance.[38]

Roosevelt agonized that his losses could prevent him from living at Sagamore Hill. He wrote to Bamie from Florence:

> *My financial affairs for the past year make such a bad showing that . . . I think very seriously of closing Sagamore Hill and going to the ranch for a year or two. . . . I must live within my income and begin paying off my debt this year, at no matter what cost, even to the shutting up or renting of Sagamore Hill, bitterly as I should hate such an alternative.*

TR added in a letter three days later: "I do love Sagamore Hill; I will not give it up if I can help." Edith was pregnant. The couple ruled out staying in the Dakotas and agreed to move into Sagamore Hill and live on a tight budget.[39]

Theodore and Edith returned to New York on March 27, 1887. At Bamie's house, they reunited with three-year-old Alice, who greeted them with a bunch of pink roses. While his daughter went to visit her grandparents in Massachusetts, TR, who had been away from Sagamore Hill for five months, and Edith relocated to the home built for his first wife and decorated by his sister. The new Mrs. Roosevelt had been in the house only once previously, a year and a half earlier when Bamie had hosted a hunt ball several weeks before TR and Edith's engagement. The couple would share Sagamore Hill for thirty-two years, and Edith would live there another twenty-nine on her own.[40]

The ever-dignified Edith was likely not pleased by the animal heads staring down from the walls and skins carpeting the floors when she stepped out of the carriage. But she accepted that the taxidermy came with her husband. TR's second wife made herself at home by installing old Carow family furniture along with the couple's acquisitions from Italy. And she staked out the white-walled parlor as her personal domain. It featured softer colors, French tapestries, elegant rugs, Sevres porcelain, a pale floral sofa and other furniture, including a small writing desk inherited from her aunt. She did admit some animal trophies into the room: a polar bear skin presented to her by Rear Admiral Robert E. Peary after his 1909 expedition in which he claimed to have reached the North Pole and lion skins that were gifts from her husband. TR chose the library across the hall as his personal space, where he could write under the gaze of a portrait of his father. The Roosevelts selected a second-floor room facing north and west as their bedroom, even though it proved to be cold and drafty.[41]

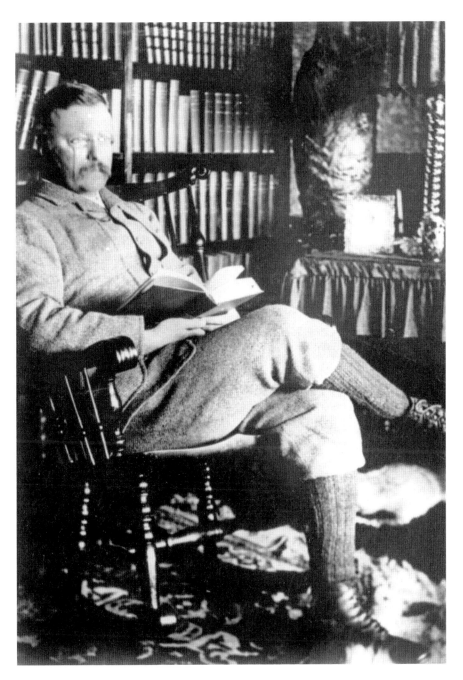

Theodore Roosevelt in the library, circa 1895. *Courtesy of the National Park Service, Sagamore Hill National Historic Site.*

When the Roosevelts moved in, TR was almost twenty-nine and without full-time employment. He was temporarily out of politics and government. Writing was his best option, as he was the successful author of *The Naval War of 1812*, published in 1882. Despite TR's love of company, the couple entertained little to save money while Theodore worked on a biography of founding father Gouverneur Morris. Over the next decade, TR would reenter public service and continue writing, but his income was never large; he periodically ruminated about being forced to sell Sagamore.

The family quickly settled into a routine. TR would carry Alice down to breakfast piggyback every morning and build woodblock houses with her. For the rest of the morning, TR would write while Edith managed the household, sewed and handled correspondence. After lunch they would walk in the woods, swim, ride or go boating.[42]

Shortly after Theodore completed his biography of Morris, Edith went into early labor on September 12, 1887, before the nurse hired to help with the delivery arrived. Dr. J. West Roosevelt was summoned from his nearby home to deliver Theodore Jr. at 2:15 a.m. the next morning. Alice welcomed her baby brother enthusiastically, practically living in a rocking chair next to his crib.[43]

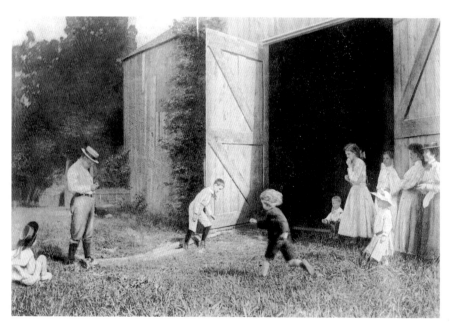

The Roosevelt family engaged in an obstacle race outside the Old Barn, circa 1894. *Courtesy of the National Park Service, Sagamore Hill National Historic Site.*

After spending the winter in New York, in April 1888 the Roosevelts moved back to Cove Neck. TR worked on his four-volume *The Winning of the West*. Edith, who preferred a relatively isolated life with her immediate family and to be alone with her books, yielded somewhat to her husband's gregarious nature and thirst for interaction with all types of people. She even reluctantly took up tennis—an activity in which her predecessor was proficient. Playing the sport at Sagamore was not for the finicky. The dirt court featured holes dug by moles, and it was covered with moss because it was so shaded by the low branches of the trees, which interfered with play. If a ball hit one, the point was played over. The

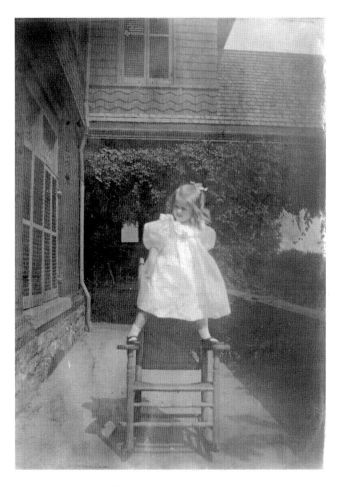

Ethel Roosevelt standing on the arms of a rocking chair on the piazza, circa 1895. *Courtesy of the National Park Service, Sagamore Hill National Historic Site.*

resident chipmunk that insisted on running across the court during games was another hazard.[44]

In May 1889, President Benjamin Harrison appointed TR to the Civil Service Commission, a position he would hold for six years. Edith was pregnant again, and her husband was in Washington on October 10 when he received a telegram from Sagamore that Edith had given birth prematurely to another son, Kermit. Roosevelt rushed for home but missed the last train to Oyster Bay. He chartered a special locomotive, which got him to Cove Neck about 4:00 a.m. Alice gained a sister when Ethel Carow Roosevelt arrived August 13, 1891.[45]

The financial panic of 1893 left the Roosevelts again short on cash, prompting renewed discussion about giving up Sagamore or at least having the rest of the family live there year-round instead of in Washington while TR continued to work in the capital. Roosevelt fretted that if his income ran behind expenses again in 1894, he would have to sell the Cove Neck property. Edith wrote to her sister, Emily, that she had begun making her own tooth powder to reduce spending. TR staved off selling Sagamore by instead selling a field to his uncle James "to get bread and butter for the bunnies," as Edith put it.[46]

Despite their financial strain, the Roosevelts had another bunny to feed when, on April 9, 1894, Edith gave birth in Washington, D.C., to Archibald Bulloch Roosevelt. He was baptized in the parlor at Sagamore Hill two months later.[47]

Roosevelt left Washington in 1895 for a two-year stint as president of the New York City Police Board. While TR was rooting out corruption, he stayed many nights at Bamie's house. But when he traveled back and forth between Manhattan and Oyster Bay, he pedaled a bicycle to the station as one of the first commuters from what would become a bedroom suburb.[48]

Roosevelt again found himself split between living in Washington and Oyster Bay when President William McKinley appointed him assistant secretary of the navy in 1897. Edith and Theodore's last child, Quentin, was delivered on November 19, 1897, in the capital. All of the children survived to adulthood despite broken bones and cuts with ensuing infections—not unusual in a hyperactive household—as well as cases of typhoid and scarlet fever, pneumonia and appendicitis.[49]

After a year of promoting both readiness for the navy and war with Spain over its treatment of Cuba, Roosevelt resigned his assistant secretary post on May 6, 1898, to help form and serve as lieutenant colonel of the First U.S. Volunteer Cavalry, the famous Rough Riders, during the Spanish-

American War. When Colonel Leonard Wood was promoted, TR assumed command in Cuba and led the charge up Kettle Hill and then San Juan Hill, which made him famous. He returned to Long Island with the regiment to be quarantined before being mustered out in September 1898. When the "Colonel," as he ever after liked to be called, returned to Oyster Bay on leave before the Rough Riders disbanded, he was welcomed by a crowd of 1,500 and a brass band. At Sagamore, he was greeted by a painted cardboard banner made by the children and tempered by Edith's restraint: "In Honor of Colonel Roosevelt's Return."[50]

A constant parade of newspapermen, politicians and other visitors came to the house to sound out its war-hero owner about his political intentions. The idea of Roosevelt running for governor of New York was widely circulated. "The house is besieged with reporters and delegations," Edith wrote to her sister. The commotion befuddled the children. When a newsman asked Archie "Where is the Colonel?" the boy replied, "I don't know where the Colonel is, but Father is taking a bath."[51]

TR penned articles about the war and signed a contract with Charles Scribner's Sons to write a book on the Rough Riders, easing the family's financial burden. The publisher sent stenographers to Sagamore so Roosevelt could dictate the story. As they worked in the Gun Room, the children came in at will and interrupted without fear of a scolding. Every day promptly at 4:00 p.m., the Colonel stopped whatever he was doing to "play bear" or another game with his children.[52]

Roosevelt learned of his nomination for governor when newsmen came to Sagamore Hill at 8:30 one evening. A delegation of GOP bigwigs followed on October 3, 1898, to make it official. They were greeted on the veranda by the candidate, who waved his hand over his head, helped them from their carriages and vigorously shook hands. Edith served lunch for thirty, giving up some of her prized isolation but warming to the idea of being a public figure in her own right. The Roosevelt children learned all of the campaign songs and sang them as they marched through the woods or across the fields. After an exhaustive series of appearances, including 102 speeches in the last week before the election, TR returned to Sagamore to rest for twenty-four hours before the voting on November 8. Theodore and Alice were in the library reading with Edith doing fancy needlework just after 8:00 p.m. when two reporters came to announce that the forty-year-old politician had been elected. The subsequent commotion roused Ted and Kermit, who slept over the kitchen. When a reporter returned to the house at 1:00 a.m. with an official message from the state Republican chairman confirming

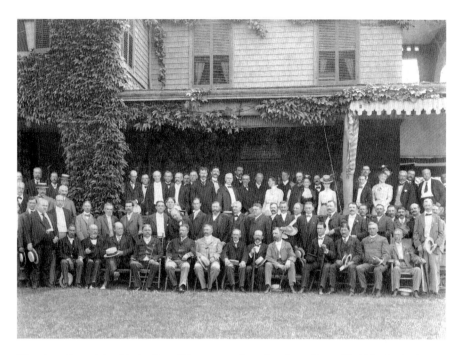

Theodore Roosevelt with the Republican committee that formally notified him he had been nominated to run for governor in 1898. *Courtesy of the National Park Service, Sagamore Hill National Historic Site.*

the results, TR was asleep. After the newsman rang the bell vigorously, the governor-elect appeared in a red dressing gown, holding a kerosene lamp. "You're elected by 18,000!" the reporter exclaimed. "Am I? That's bully!" TR responded before allowing the messenger inside briefly to warm up before going back to bed.[53]

Two years later, after riling the state party hierarchy, Roosevelt was nominated to run for vice president with McKinley. Less than a week later, on July 12, TR was notified officially at a ceremony at Sagamore Hill. Dressed in formal wear, the candidate greeted the GOP notables by the porte-cochère with a handshake for each. The nomination brought even more newsmen and other visitors to the house. When two men with cameras came out of the woods near the water and photographed his children swimming, TR lost his temper and threatened legal action. Despite the hubbub, the house felt more empty and quiet when Edith took Ted to Groton School in September for his first year.[54]

The Republican ticket was victorious on November 6. TR, clad in a nightgown, learned the news from a reporter at 5:00 a.m. He alerted the

Theodore Roosevelt and President William McKinley at Sagamore Hill, 1900. *Courtesy of the National Park Service, Sagamore Hill National Historic Site.*

family, got dressed and came out to address the newsmen. "I am delight—" he managed to say before a stiff wind blew a reporter's hat off, and the vice president–elect ran to retrieve it.[55]

Since the family's money troubles were not over, Theodore and Edith decided to spend the winter at Sagamore as an economy measure. Only from May 1900 to September 1901 did the Roosevelts remain in Cove Neck for a full year. Although built as a year-round home, during these years Sagamore Hill was primarily a summer residence, not only because it was difficult to heat but also because TR's work often required him to be in Washington, Albany or New York City for much of the time. The family typically moved out to Cove Neck in May or June and remained until October, although sometimes they resided there as late as December.

Having grown up in a wealthy family and not being good at managing money, Roosevelt was grateful to turn over the family finances to Edith. She was a shrewd penny-pincher who gave him daily pocket money of $20,

which he could rarely account for by dinner. TR had inherited about $25,000 from his father but had serious losses from his cattle-ranching ventures. His salary as Civil Service commissioner in Washington was $3,500, low even by the standards of the 1890s. When he became president of the New York City Police Board and had to live in the city for the winter, finances became even tighter. Serving as vice president did not resolve the problem. TR wrote Bamie that if he had to sell Sagamore Hill, his children would reproach him for not making more money with a different career path.[56]

Even though Edith worked tirelessly to rein in the family's expenses, initially she still employed a cook, waitress, chambermaid and nurse to take care of Alice. That was Mary Ledwith, called Mame, an Irish immigrant employee of the Carow family who had cared for Edith since infancy. There was also a resident farmer, Noah Seaman, and a boy helper. By 1890, a second maid and a laundress had been added. Mame was reliable, and the family was generally fond of her, but she could try Edith Roosevelt's patience, especially in her later years, until she left the family's employ in 1908. "Mame is . . . as cross as two sticks," Edith wrote to her sister in 1893. Mame's job was to oversee the children once they were no longer infants. The babies were under the care of a "lying-in" nurse initially and then a resident nursemaid before Mame took over.[57]

Edith wrote out responsibilities and schedules for the staff on notepaper now in the Harvard University library. Her meal schedule for the cook was as follows: kitchen breakfast, 7:30 a.m.; dining room breakfast 8:30 a.m.; kitchen dinner 12:30 p.m.; dining room lunch 1:30 p.m.; kitchen tea 5:00 p.m.; dining room dinner 7:30 p.m. Additionally, the cook was expected to dust the stairs, kitchen hall and scullery every day, on Tuesdays clean the hall stairs and servants' sitting room and on Thursdays clean the kitchen and scullery. The earliest maid who was named in Edith's account books in the Harvard archives is Alice Fraser, in 1892–93. Besides her regular cleaning chores, her duties were to care for infant Ethel while Mame had breakfast and supper and answer the door while the waitress dressed and helped with company. The family employed a governess for Alice in New York in 1895–96, but she did not live with the family. The first live-in governess was a Miss Young, hired in November 1898 to supervise headstrong Alice, then fourteen, who had threatened to "humiliate" the family if her parents sent her to boarding school.[58]

Based on the low turnover rate, the Roosevelts did not seem to have a problem finding and keeping good servants, unlike many other prominent families, who complained about the issue. "Is it not lucky that the servants

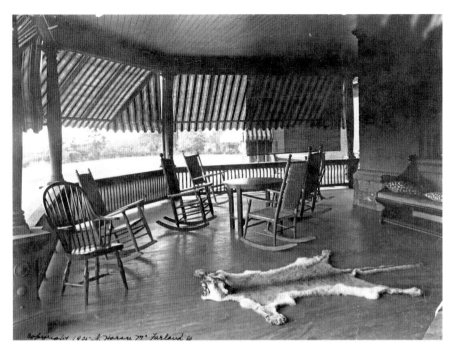

The piazza in 1905. *Courtesy of the National Park Service, Sagamore Hill National Historic Site.*

are so good?" Edith wrote to her sister in 1901. But the high retention rate probably was even more of a testament to her intelligence and management skills.[59]

Edith's detailed account books show in her neat script what she was paying for food, staff and other expenses and also income from the modest farm operation. In June 1894, for example, she paid three grocers a total of $29.22, $39.50 for oats, $5.03 for fish, $39.42 to the butcher, $6.25 to a carpenter, $36.88 for a blacksmith and $1.50 for a subscription to the *Long-Islander* newspaper, among other expenses. She often paid her bills within a few days of receiving them but sometimes waited several weeks.

Besides routine expenses, there were occasional bills for upgrades. In December 1890, Edith wrote to her sister: "I'm having double windows put all over the north side of the house today to the tune of $160, but I hope to save something in coal besides keeping approximately warm." In a letter to Bamie, she lamented the expense of the storm windows, "but we should have frozen without them." She had moved temporarily to the old nursery because her own room facing north and west was "so cold that I could not have laid [*sic*] in bed there." TR wrote to Bamie on the day after

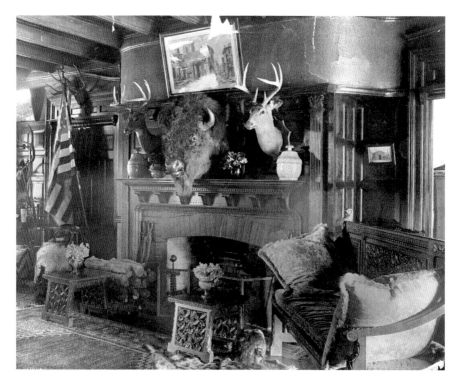

The front hall in 1904, when it still served as the family living room. *Courtesy of the National Park Service, Sagamore Hill National Historic Site.*

Christmas in 1896 that "the roaring wood fires keep at least . . . the living rooms warm." Conversely, the house was always hot in the summer, even before the Theodore Roosevelt Association removed the central ventilation shaft in 1953. An 1893 expenditure of $800 was paid to "refinish house," which probably included installing a fireplace in the children's bedroom in the northeast corner of the second floor and wallpapering rooms on that floor. In April 1901, Edith turned her old parlor into the modern drawing room, redecorated the former schoolroom on the top floor to become a guest room for her sister and renovated the old nursery on the southwest corner of the second floor into a dressing room for TR.[60]

Edith Roosevelt's account books also provide a window into agricultural operations. Sagamore Hill was a working farm, with horses, cows, hogs, chickens, wheat and rye fields, an apple orchard and a three-acre vegetable and fruit garden northeast of the house. Hogs were cleaned and butchered in a shed in the fall and then hung in the smokehouse. Between twenty and forty acres of the property were cultivated from year to year. The cultivated

fields were south, east and to the far north of the house. Hay and clover pastures were to the east along with the orchard. The fields and pastures were separated by rustic wooden rail fences. A large meadow lay to the west and southwest of the house. To the north were tree-studded lawns.

The account books have pages headlined "Received from Farm" for 1891 and from 1893 through the end of the century. In 1891, a record year, the page lists hay and straw, wheat, rye, corn, eggs, butter, apples, pumpkins, melons, potatoes, asparagus, calves, old cows and ponies with a total of $881.11 for the year. The proceeds fluctuated, but the scale of the farming tapered off over time, hitting a low of $57.48 in 1899.[61]

To support the farm and gardens, a gardener's shed, chicken house and a hog slaughtering shed (renamed the farm shed by the National Park Service) were built between 1885 and 1900 to supplement the Old Barn. The combined chicken coop and toolshed was a frame building forty by fourteen

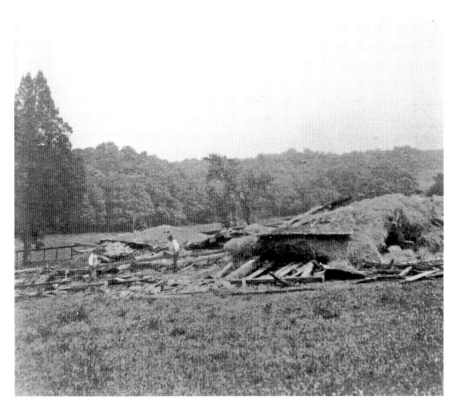

Photograph in Edith Roosevelt's scrapbook of the Old Barn after its collapse around 1904. *Houghton Library, Harvard University.*

feet that housed approximately one hundred chickens. The hog shed was a clapboard structure approximately twelve by eighteen feet. A windmill was erected between 1884 and 1886 to pump water for the estate.[62]

The gardens were splashed with color from carnations, petunias, marigolds, zinnias and snapdragons. There were peach, pear, plum and cherry trees along with currant, gooseberry and grape bushes. The vegetables were planted on the eastern side and included corn, asparagus, beans, beets, carrots, potatoes, tomatoes, lettuce, cantaloupes, watermelons, strawberries and raspberries.[63]

The gardens, fields, woods and shoreline and the books, nooks and crannies of the lively house made growing up at Sagamore Hill one continuous adventure for the Roosevelt children. The guide for this adventure was larger-than-life TR. "We particularly valued Father as a companion," Ted wrote. "He could think of such delightful things to do." Quiet, loving support and occasional restraint was supplied by their mother.[64]

Sagamore Hill summers brought together a pack of rambunctious and inquisitive children. Each of Theodore and Edith's progeny had a cousin his or her own age at the nearby homes of Emlen and J. West Roosevelt. Other cousins, such as TR's niece Eleanor, were also frequent guests. To entertain their father and other relatives, the Roosevelt sons, cousins and friends once organized a circus in the barn, in which they performed tricks.[65]

TR wrote in the *Outlook*, a weekly magazine:

> *There could be no healthier and pleasanter place in which to bring up children than in that nook of old-time America around Sagamore Hill. Certainly I never knew small people to have a better time or a better training for their work. . . . They were never allowed to be disobedient or to shirk lessons or work; and they were encouraged to have all the fun possible. They often went barefoot, especially during the many hours passed in various enthralling pursuits along and in the waters of the bay. They swam, they tramped, they boated, they coasted and skated in winter, they were intimate friends with the cows, chickens, pigs, and other live stock. They had in succession two ponies.[66]*

One of the ponies, a gift to Alice from her grandparents, was named General Grant. It was beloved by all the children, with the exception of the time that the horse tried to eat Ted's straw hat when he was three. The horses were a small part of a revolving menagerie. There were many dogs, of course. Also numerous were guinea pigs, named—without regard to the sex of

the animal—by the children for important figures such as Admiral George Dewey. They named a pig for Mame, who failed to appreciate the honor. Hens received the names of characters in books their parents read to them. There were also rabbits, flying squirrels, kangaroo rats, a short-tempered but basically friendly badger and even a young black bear the children christened Jonathan Edwards. Many of the animals ended up in a small space about 220 feet north of the house that was used as a pet cemetery between 1902 and 1917. It was marked by a stone dedicated to "Faithful Friends."[67]

TR immersed the children in the wonders of nature as soon as they could walk. They learned the names of birds and flowers. One of their favorite spots was the "wood-pile pond" adjacent to where the wood that TR and others chopped was stored. Ted described it as follows:

> *A noisome bit of stagnant water and black mud into which the pig-sty drained. We liked it particularly because countless turtles sat on the rotten logs that lay there, or slowly swam over its surface, their heads sticking out of the green scum like small periscopes.*[68]

Along with appreciating nature, sports and physical activity were prized at Sagamore Hill. Prominent in the memory of family members and guests were "scrambles" around the property, particularly a subset: TR's "point-to-point" hikes. "This consisted in selecting some landmark and going to it without turning aside for anything," Ted would write. "If a haystack was in the way we either climbed over it or burrowed through it. If we came to a pond we swam across." As the scrambles became more strenuous, Edith dropped out. But TR continued to lead the boys, for whom "a tear in a pair of trousers was . . . rather a badge of honor."[69]

Some of the scrambles and other Roosevelt activities would horrify modern-day parents. TR wrote to Bamie about finding a hollow tree with an opening twenty feet above the ground. "The other day, with much labor, I got up the tree, and let each child in turn down the hollow by a rope."[70]

Two locations were frequently mentioned by Roosevelts and their guests as the biggest sources of excitement. TR wrote:

> *One of the stand-bys for enjoyment, especially in rainy weather, was the old barn. . . . It stood at the meeting-spot of three fences. A favored amusement used to be an obstacle race when the barn was full of hay. The contestants were timed and were started successively from outside the door. They rushed inside, clambered over or burrowed through the hay, as suited them best,*

dropped out of a place where a board had come off, got over, through, or under the three fences, and raced back to the starting point.[71]

Ted wrote, "We kept our records with as much care as if we were competing in the Olympics." The barn was also a frequent site for playing hide-and-seek. "We tunneled the hay until it was like a rabbit warren." And nearby was another attraction: "The stable, a disjointed rambling building full of musty corners and promising mysteries. Old harness, saddles, eel spears, and a hundred other oddments are piled in the dark under its eaves."[72]

The other favorite spot was Cooper's Bluff. The steep glacial hill on its northeast corner of the Cove Neck peninsula overlooking the harbors and the sound was located a mile from the Sagamore Hill residence on the property of TR's cousin Emlen. TR often took his children, other young relatives and guests there to run up or down the sandy slope rising from the beach. Ted recalled:

One late autumn afternoon when Mother was not with us, we had a race down the bluff.... One after the other tripped and fell.... We reached the bottom, dusty, bruised and breathless. This was all very well for the boys, who enjoyed it greatly and to whom a scar more or less made no difference, but my sister Alice got a gash on her forehead. When we reached home, Father was in deep disgrace.

"If the tide was high there was an added thrill, for some of the contestants were sure to run into the water," TR wrote.[73]

The water was an irresistible attraction. A dock was built out into Cold Spring Harbor in June 1890 at a cost of $29.24, but it no longer existed by 1906. There was a floating wooden platform anchored off the beach that took the place of a fixed dock. The Roosevelts frequently used the dock on W. Emlen's property to the north. TR's method for teaching the children how to swim was simple: drop them off the end of the pier into deep water. They might be horrified at the prospect, but knowing they had to keep up the family tradition, they all jumped, as did the cousins, including Eleanor, the future First Lady.[74]

TR noted:

As soon as the little boys learned to swim they were allowed to go off by themselves in rowboats and camp out for the night along the Sound. Sometimes I would go along so as to take the smaller children. Once a

schooner was wrecked on a point half a dozen miles away. . . . This gave us a chance to make camping-out trips in which the girls could also be included, for we put them to sleep in the wreck, while the boys slept on the shore: squaw picnics, the children called them.[75]

Edith was surprisingly tolerant of the exuberant outdoor activities organized by TR with his cousins West and Emlen, and she often joined in. But she also knew when to rein in her husband. Even as vice president of the United States, Roosevelt was not exempt from the wrath of his wife and other mothers when he took his children, the neighboring cousins and their mothers on an all-day picnic. It featured a menu of what Ted recalled was "baked clams and cinders, sandwiches and sand." While the mothers rested in the shade, sewing and chatting, TR took the children for a walk. When they wanted to go in the water, he let them go wading in their clothes. But soon they were swimming, and their mothers were not thrilled with their wet, sandy appearance. Ted described the long row home as very quiet, with his father "pretending that he was not there."[76]

Theodore and Edith also enjoyed the water together without children and the associated drama. TR would launch a rowboat into Cold Spring Harbor and then row them for miles to nearby beaches or marshes while they read Browning and other poetry. The family had a bathhouse situated on the Cold Spring Harbor beach as early as 1888 and also a boathouse.[77]

Riding was an integral part of life at Sagamore. The children had their ponies, while Theodore and Edith had riding horses, including TR's prized hunter, Sagamore. Roosevelt enjoyed foxhunting and other cross-country rides as well as polo. As a proponent of what he called the "strenuous life," TR not only hiked point-to-point but rode horseback the same way. That was not appreciated by the local farmers whose fields he crossed. Edna T. Layton, who grew up on a farm in East Norwich just south of Oyster Bay, wrote in a memoir, "It was not uncommon for him to ride right across my Grandfather's farm. He did not go around the field, but right across it, thus ruining whatever crops his horse stepped on. This made nearby farmers very angry."[78]

Roosevelt, who had ridden with the Meadowbrook Hounds and sponsored foxhunting meets since the house was built, wrote in *Century* magazine, "There are plenty of foxes around us, both red and gray . . . Skillful and daring horsemanship is called for . . . over such an exceedingly stiff country." TR never lacked for daring, as evidenced by his broken arm.[79]

The Fourth of July was a special day for the children. They acquired firecrackers and other fireworks, and TR supervised their ignition. Winter

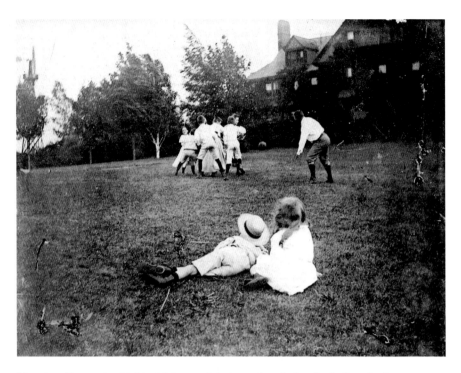

Theodore Roosevelt with his children and their cousins playing football on the lawn at Sagamore Hill with Kermit and Ethel in the foreground, circa 1894. *Courtesy of the National Park Service, Sagamore Hill National Historic Site.*

brought sledding, sleigh rides and snowball fights. After TR learned about cross-country skiing from a Norwegian employee at the Smithsonian Institution in Washington, the sons at home got to try that as well.[80]

Not surprisingly, in living the strenuous life, Roosevelt, as well as his children, were often injured. He was battered regularly in polo matches and even performing household chores. TR managed to escape serious injury, despite spending hours at one of his favorite activities—chopping wood. But when the windmill became stuck one summer, TR grabbed an oilcan and climbed the sixty-foot framework just as the wind veered, causing the vane to swing around and remove a slice from his scalp. Retreating to the house covered in blood, he was greeted in the front hall by Edith. Familiar with such occurrences, she remarked, "Theodore, I should wish you would do your bleeding in the bathroom. You're spoiling every rug in the house."[81]

The fact that the house included the Gun Room illustrates that firearms played an important part in the life of the Roosevelts. TR taught the children

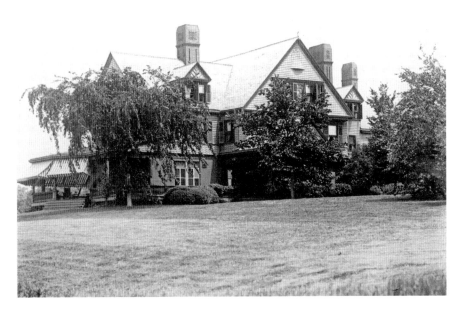

The house with mature trees, circa 1904. *Courtesy of the National Park Service, Sagamore Hill National Historic Site.*

about guns and how to use them properly from an early age. Squirrels and other small animals on the property were targets. Roosevelt paid Archie to shoot crows from the Gun Room windows on the third floor, presumably because they ate corn growing on the property.[82]

But there were instances when weapons were fired with questionable judgment. When Ted was nine, TR presented him with his first gun, but it was too dark to go outside to try it out. Ted brought the Flobert rifle to his father while he was dressing for dinner and wondered whether it was real. His father put a cartridge into the chamber and said, "You must promise not to tell mother." He then fired the weapon into the ceiling with such slight noise, very little smoke and a tiny hole that Edith was never the wiser. Ted wrote about the cousins practicing with a new rifle, using the side of the bathhouse as a target. The next day, his father tried on a new bathing suit that was hanging inside the shed to show it to his friends. "They looked at it, and found that the seat of the trousers was punctured with a series of holes like the bottom of the sieve."[83]

Other than the rifle bullet in the ceiling, the house was the scene of more serene activity than the barn or two-hundred-foot-high Cooper's Bluff. Ted wrote:

> *On three sides runs a broad verandah. . . . The Northwest looks towards the Sound, beyond which rise the blue hills of Connecticut. Big battered armchairs stand in groups. In the evening we gather there in the restful dark and talk to the creak of the rockers. . . . When the lights of the* [Fall River] *boat from New York had passed out of sight behind Lloyd's Neck, it was the rule that the young ones should go to bed.*[84]

TR did roughhouse with the children inside the house regularly, to the point that Edith asked him not to do it in the evening because they would not be able to sleep. The Gun Room, filled with TR's books and firearms, was a magnet for the children, especially inside a crawlspace between the rafters that was filled with all sorts of mysterious treasures.[85]

Meals were lively, with Theodore leading the wide-ranging discussions and his wife trying to maintain a measure of decorum. When the children were old enough to act properly, they were allowed to stop eating in the nursery and join the rest of the family in the dining room, with the eldest next to TR and the youngest next to Edith.[86]

There were guests at the table for many those meals. The most frequent visits were from relatives, particularly Theodore's sisters and members of the two other Roosevelt families living in Cove Neck. "Sagamore Hill is one of three neighboring houses in which small cousins spent very happy years of childhood," TR related in his autobiography. "In the three houses there were at one time sixteen of these small cousins."[87] Theodore and Edith's children also spent lots of time at neighboring Roosevelt homes, often at mealtimes. Ted wrote:

> *My cousins' family used to have breakfast at seven. My family had breakfast at eight. Both families had old-fashioned American meals—cereal, waffles, corn-beef hash, beefsteak, potatoes. We boys were accustomed during the summer to breakfast regularly at both houses. The half-hour in between and the half a mile walk was all that we needed to whet our appetites again. The pantry at Sagamore, of course, had to be kept locked, or we would have gorged there continually.*[88]

As TR's political career and other interests developed, there was an increasing stream of non-family visitors. TR's predilection for inclusiveness

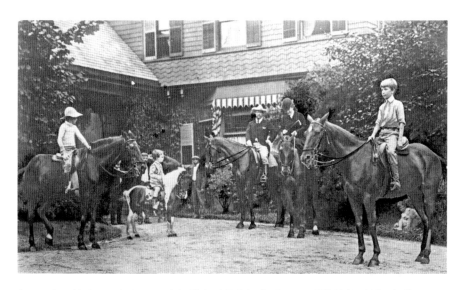

A morning ride in 1902. *Courtesy of the National Park Service, Sagamore Hill National Historic Site.*

could cause headaches for his wife. Edith wrote to her sister in 1899 that she had left Oyster Bay on a Thursday after having "ordered lunch for nine to be ready on Sunday and by the time I got back my lunch had grown to twenty-two including the governor-general of Canada and Sir Thomas Lipton," the tea magnate and yacht racer.[89]

Relatives and favored guests, such as Cecil Spring-Rice, the English diplomat who had been TR's best man at his wedding to Edith, might stay for a month. Other prominent visitors included politician Henry Cabot Lodge, artist Frederic Remington, novelists Edith Wharton and Edna Ferber, writer-reformer Jacob Riis, prizefighter John L. Sullivan and British playwright James M. Barrie, creator of Peter Pan.[90]

With all of the activity, the Roosevelt children loved living in the large informal house. "As the children grew up, Sagamore Hill remained delightful for them," Roosevelt recounted in his autobiography. "There were picnics and riding parties, there were dances . . . and open-air plays on the green tennis court of one of the cousin's homes."[91]

In his autobiographical *All in the Family*, written in his late twenties, Ted recounted:

> *The house has that air of having been lived in. . . . It never was and never will be entirely in repair. There are always boards missing in the lattice*

under the piazza. . . . We would not wish it to be groomed like a war-profiteer's mansion just delivered from the hands of an interior decorator.[92]

The family loved the house the way it was so saw little need for change. Despite TR's exuberance and impulsiveness, those changes that were made, especially the introduction of new technology, were done conservatively, more in keeping with Edith's sensibilities. For example, the ringing of a telephone was not heard until 1902, and then only because Roosevelt had become president and Sagamore Hill was the Summer White House. Before that, anyone who wanted to speak with TR had to call an Oyster Bay drugstore, which would dispatch a boy on a bicycle to take the message up the hill.[93]

4
The Summer White House

On September 14, 1901, Theodore Roosevelt was sworn in as the twenty-sixth president. At age forty-two, he became the nation's youngest chief executive. The unexpected change in circumstances followed President McKinley's trip to Buffalo for the Pan-American Exposition, where he was shot by an assassin on September 6. Initially, McKinley was expected to survive, but a week later he died—before TR could reach the city.

With Roosevelt and his family moving into the White House, Sagamore Hill lay dormant until midway through the following year, when it became the Summer White House. On July 5, 1902, the president returned to Oyster Bay accompanied by his secretary, George Cortelyou; two stenographers; two New York detectives; two post office inspectors; and two members of the recently created Secret Service. TR and some of his children, who greeted him at the station, rode the two miles to Cove Neck in open carriages during a heavy rainstorm.[94]

Before his ascension to the White House, TR had always spent the Fourth of July with his children. But in his first summer as president, he traveled to Pennsylvania to give an Independence Day speech in Pittsburgh. Without their father's usual supervision, the boys exploded their fireworks on their own. After Kermit nearly blew off his hand by igniting a firecracker in a bottle, a nonplussed TR read about it in a newspaper on his way home. "I suppose that is to be expected of the family," he commented. To compensate for his absence on the holiday, the president invited neighbors and cousins to join the family for a fireworks show two nights after arriving at Sagamore.[95]

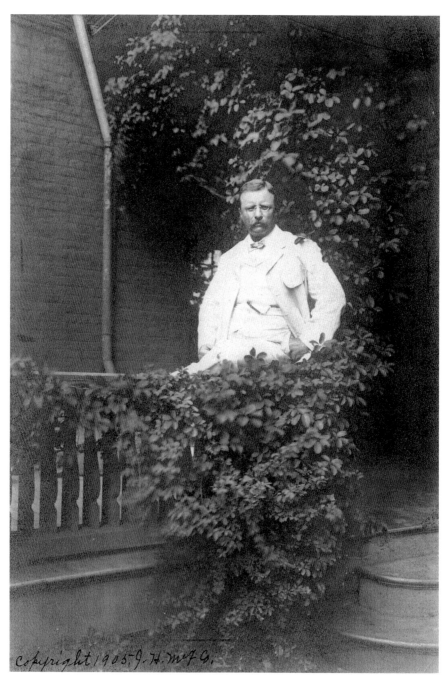

Theodore Roosevelt seated on the piazza, 1905. *Courtesy of the National Park Service, Sagamore Hill National Historic Site.*

Cortelyou and the stenographers established offices on the second floor of the Oyster Bay Bank Building while telephones were installed in the pantry and library at Sagamore Hill.[96]

The president's summer routine was later described in a *Broadway* magazine profile: the day began with "him bounding out of bed" no later than 7:00 a.m. and taking a "shower bath" in water as "cold as he can get it." TR would come down for breakfast wearing riding clothes. "The President isn't dainty in the matter of appetite." Eggs, fried chicken and sometimes waffles were on the menu. He would spend ten to twenty minutes reading items requiring immediate attention in the library before heading out on horseback for about two hours with his wife or sons. After his "morning constitutional," at 10:30 a.m., secretary William Loeb, successor to Cortelyou, would arrive in a big white Secret Service automobile with up to three assistants bringing mail in leather pouches. The correspondence took two hours. "Secretary Loeb and his assistants do not look any too fresh when they resume their seats in the white automobile and are taken back to the Executive Offices in the village." TR, however, still had plenty of energy for the afternoon's visitors who arrived at 1:00 p.m.[97]

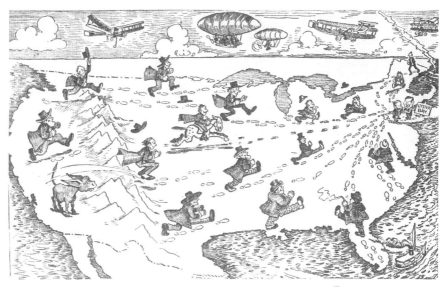

ALL ROADS LEAD TO OYSTER BAY

A political cartoon about the attention focused on Oyster Bay when President Theodore Roosevelt spent his summers there. *Courtesy of the National Park Service, Sagamore Hill National Historic Site.*

Even though he was now running the country, no matter how important the visitor, TR continued his policy of stopping work to play with the children at 4:00 p.m. One day in that first July as president, he was in the library discussing Cuba with a visiting statesman when his sons and cousins gathered at the door. "Cousin Theodore, it's after four," one of them implored. "By Jove, so it is!" the president replied. "Why didn't you call me sooner." Turning to his visitor, Roosevelt said, "I must ask you to excuse me . . . I promised the boys I would go shooting with them at four o'clock, and I never keep boys waiting."[98]

As president, TR's spur-of-the-moment recreational adventures with family and guests included the old stalwarts of horseback riding, rowboat excursions, clambakes or picnics on a beach and, of course, running up or tumbling down Cooper's Bluff. But now they could also be grander, such as a trip down Long Island Sound on the presidential dispatch boat *Sylph*. The "point-to-point hikes" or "obstacle walks" also continued but now included even more important visitors and fears for the safety of the chief executive. Roosevelt wrote to James R. Garfield, future secretary of the Department of the Interior, about one hike:

> *We swam the mill-pond, in great shape, with our clothes on; executed an equally long but easier swim in the bay, with our clothes on; in between times had gone in a straight line through the woods, through the marshes, and up and down the bluffs. . . . I did not look exactly presidential when I got back from the walk!*

TR's sister Corinne recalled going on an obstacle walk with a course that took them toward an "especially unpleasant-looking little bathing-house with a very steep roof." She hoped in vain that her sibling would go around it. "I can still see the sturdy body of the President of United States hurling itself at the obstruction and with singular agility chinning himself to the top and sliding down on the other side." The children, whooping with pleasure, and his sister followed. The obstacle walks were conducted with strict safety rules—for the children but not the president. If a child fell climbing a tree because he did not use both hands or fell in while crossing a brook, he was sent home.[99]

The long-treasured planned activities also continued into the presidential years. The highlight of the summer for the sons and male cousins continued to be the annual "camping out" adventure. These were open to anyone who could dress himself and "understand that, when once off, all ills from mosquitoes to a downpour of rain must be borne not only uncomplainingly

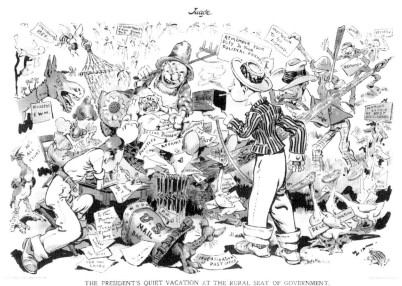

THE PRESIDENT'S QUIET VACATION AT THE RURAL SEAT OF GOVERNMENT.

A political cartoon from *Judge* magazine depicting President Roosevelt's frenzied activity when Sagamore Hill was the Summer White House. *Courtesy of the National Park Service, Sagamore Hill National Historic Site.*

but cheerfully," TR stated. The sites were usually five or six miles away and reached by rowboat. "The boys are sufficiently deluded to believe that chicken or beef-steak I fry in bacon fat on these expeditions has a flavor impossible elsewhere to be obtained," he wrote to a friend. The nights ended with TR telling stories of his exploits around the fire.[100]

On some outings, Roosevelt decided he did not need to be under the scrutiny of his security detail or the press corps. On one occasion, he eluded them to camp out on a headland farther east with Ted, Kermit and a cousin. The chief executive's most famous adventure with the boys and without the Secret Service was a horseback ride to the home of his cousin John Ellis Roosevelt on the South Shore. TR, Ted and two cousins rode all night and well into the next morning to cover the thirty-five miles to Sayville through a heavy rain. They returned the next day, leaving Sayville at 4:00 a.m. and getting back to Cove Neck just before lunchtime. "I am glad to see you safely home, Mr. President," Edith greeted him matter-of-factly. The *New York World* was unimpressed by the feat, quipping in an editorial, "Now that the President has proved by actual experience that the trip from Oyster Bay to Sayville and back can be made on horseback, with what new discovery will he next thrill a waiting nation?"[101]

The First Couple made sure they had time to themselves for picnics or galloping across the countryside. Edith sometimes joined her husband in his regular pastime of chopping down trees. She would wield an axe and remove branches from trees TR had felled.[102]

During the presidential years, the Roosevelt children began to disperse to pursue their education or, in the case of Alice, marriage. Fiercely independent and impetuous, Princess Alice, as she was known in the press, spent less time at Sagamore as she got older. She traveled widely and stayed with high-society friends. She visited more rarely after marrying Ohio congressman Nicholas Longworth in February 1906. But she always came to Cove Neck for holidays, summer gatherings and important family events and emergencies. Ted and Kermit were away at school but enjoyed their summers in Oyster Bay. Kermit's 1908 diary describes activities such as playing the mandolin while Ethel played the piano and target practice with his father. With Alice gone, by 1907 all of the remaining children had separate bedrooms. Kermit had Alice's old room in the southeast corner of the second floor. Ted was on the third floor and Ethel in the old nursery, also known as the Gate Room.

Quentin Roosevelt in his wagon "Studebaker" as farmworkers bring in hay in a photograph from Edith Roosevelt's scrapbook. *Houghton Library, Harvard University.*

Archie was in the northeast room on the second floor with Quentin in a small space behind Archie's room known as the "Hide-Away."[103]

As the Summer White House, Sagamore Hill initially functioned with approximately the same number of servants as before. A chambermaid replaced the seamstress and nursemaid. Her nursing duties for the boys no longer necessary, Mame remained as a sort of retired nanny until September 1908. The waitress gave way in 1906 to a black male butler and assistant butler who had worked at the White House, Charles Reider and James Amos. The latter became chief butler, with Allen Dean as his assistant. They lived in outbuildings.[104]

With TR now president, the number of visitors swelled. Special guests might be picked up in the city or in Connecticut by *Sylph* and brought to a dock in Cove Neck. Some wealthier visitors, such as J.P. Morgan, came on their own yachts.[105]

Among the important persons who came to Sagamore in its first year as the Summer White House was New York State political boss and U.S. senator Thomas Platt. When her husband's meeting dragged on past the lunch hour, Edith sent Archie to intervene. TR pretended to be offended, calling his son an "abominable little rascal." As they went into lunch, the highly formal senator asked the smiling First Lady if she approved of "this strange behavior." Platt later told a reporter for the *New York Journal* that he was exhausted by his visit, adding, "I have climbed Sagamore Hill. I do not think I shall attempt it again. I am getting too old."[106]

Most guests, however, were enthralled. "They were all in excellent spirits," the *New York Sun* noted after interviewing some of them.

Other important visitors that summer included Secretary of State John Hay, Secretary of War Elihu Root and the man the president would name as the first head of the U.S. Forest Service, Gifford Pinchot. TR liked to have an interesting mix around the table, and he would lead his lunch guests in discussing history, literature, politics and science. TR particularly valued the company of naturalists such as John Burroughs, who came in 1907 and walked the property with the president listening to bird songs. George Bird Grinnell, who edited three books with TR on North American big game, worked with Roosevelt at Sagamore to found the Boone and Crockett Club for hunters committed to conservation.[107]

"In one afternoon, I have heard him speak to the foremost Bible student of the world, a prominent ornithologist, a diplomat and a French general, all of whom agreed that Father knew more about the subjects on which they had specialized than they did," Archie marveled.[108]

The President and his family are at Oyster Bay,
seeking rest and privacy

Political cartoon from an Ohio newspaper in 1902 when Sagamore Hill was the Summer
White House. *Courtesy of the* Columbus Dispatch.

On July 27, 1904, the guests were Republican notables who came to
formally notify Roosevelt that he had been nominated to run for the
office he assumed upon McKinley's assassination. TR waited under
the porte-cochère in a frockcoat and white waistcoat for the committee
chaired by Speaker of the House Joseph G. Cannon. The committee, family
members, friends and staff—totaling about 150—gathered on the piazza
to hear Cannon's remarks. Then the group assembled on the lawn for
photographers and refreshments served by the Roosevelt children and
cousins.[109]

A few days after gaining the presidency via the electorate, TR wrote to
fifteen-year-old Kermit at Groton about the "overwhelming victory . . . the
greatest popular majority and the greatest electoral majority ever given to
a candidate for president." But he added that "the really important thing
was the lovely life I have here with Mother and with you children, and that,

Quentin Roosevelt seated on the icehouse roof, circa 1905. *Courtesy of the National Park Service, Sagamore Hill National Historic Site.*

compared to this home-life, everything else was a very small importance from the standpoint of happiness."[110]

The increased and always unpredictable flow of guests, many unannounced, for meals or overnight stays was a constant source of exasperation and stimulus for improvisation by the First Lady. Visitors often remarked about her unruffled nature, not realizing she kept her displeasure hidden while she and cooperative servants scrambled.[111]

Among the uninvited seeking an audience with the president was Captain Joshua Slocum, who had sailed his forty-foot sloop *Spray* solo around the world. After meeting with TR, he took Archie for a weeklong cruise. Another seafarer who dropped anchor in Oyster Bay was Robert E. Peary on his way

to the North Pole in a vessel he had named *Roosevelt* to inspire his crew. "I believe in you, Peary, and I believe in your success—if it is within the possibility of a man," the president said in endorsing the enterprise.[112]

Continuing to shed some of her reticence, Edith welcomed most visitors, invited or otherwise. But she balked when the Russian ambassador, Count Cassini, sought an invitation for Grand Duke Boris, who had exhibited scandalous behavior in his trip across the country. Since the duke was a cousin of Czar Nicholas II, the president realized refusing to receive him could have political consequences. But the First Lady insisted that having him in the house would be an insult, and she would not abide having him at her dining room table. The ever-practical Edith resolved the issue by arranging a lunch invitation of her own down the hill at Yellowbanks with the president's aunt Lizzie on the day of the grand duke's visit.[113]

To demonstrate that he had not lost touch with his neighbors and probably to make amends for the disruptions caused by having a president in their midst, Roosevelt invited them all to Sagamore Hill at the end of his first summer as chief executive. The word went out through the newspapers and announcements at local churches. More than eight thousand people came to the flag-bedecked house. They snacked on gingersnaps and other refreshments while TR, dressed in a frockcoat, shook hands and declared that he was "dee-lighted" to see them. One reporter estimated Roosevelt was capable of shaking sixty hands per minute. After TR had spent two hours on the receiving line, a woman commented, "Mr. President, how tired you must be!" "Not a bit!" Roosevelt responded in his high-pitched aristocratic voice. "It takes more than a trolley car to knock me out, and more than a crowd to tire me." He then went on to shake hands for two more hours. Those who arrived early went home with souvenir punch glasses etched with "Theodore Roosevelt 1902."[114]

Ever since McKinley's assassination, Edith Roosevelt worried about her husband's safety. The Secret Service agents guarded the access road to the property and patrolled the perimeter. Guests invited by the president were cleared by the office in Oyster Bay and their names sent up to the Secret Service. The agents tried to keep unexpected, and especially unbalanced, visitors away. Only days after TR arrived for his first summer as president, a defrocked priest with a grievance about a bishop showed up and was turned away. Roosevelt, who was playing tennis, remained unaware. Not all unwanted visitors were harmless. The following summer, a deranged farmer from Syosset, five miles to the south, appeared on the access road in a buggy with a revolver in his hand and told the Secret Service guard he had

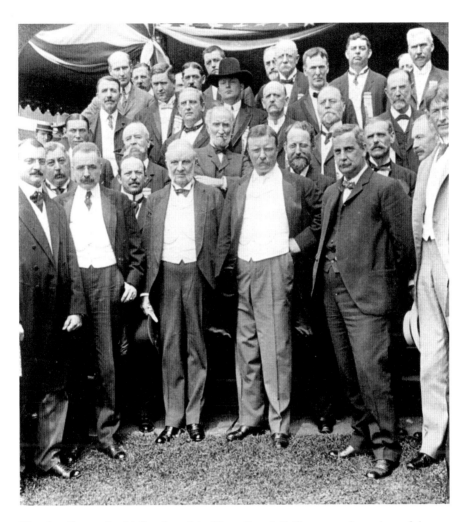

Theodore Roosevelt with Speaker of the House Joseph G. Cannon and members of the Republican committee that came to Sagamore Hill to formally notify the president that he had been nominated to seek a full term in 1904. *Courtesy of the National Park Service, Sagamore Hill National Historic Site.*

an appointment with the president to discuss his unemployed brother. Sent away, he returned fifteen minutes later and claimed the president wanted him to marry Alice. Told to make an appointment the next day with the president's secretary in Oyster Bay, the man left but returned a quarter hour later. Again confronted by the Secret Service, the farmer saw the president open the door and urged his horse forward as a security guard dragged him to the ground. "I wanted to kill him," the farmer conceded later.[115]

Serving as leader of the nation meant less time at Sagamore Hill because Roosevelt could spend only a few weeks away from Washington at a time. But that meant he cherished his visits even more. "We were all of us, I am almost ashamed to say, rather blue at getting back to the White House simply because we missed Sagamore Hill so much," TR wrote in the fall of 1905.[116]

Despite the attractions and distractions of Cove Neck, TR remained fully engaged in his presidential duties when at Sagamore. With Russia and Japan engaged for more than a year in a war that Japan was winning but both sides wanted to end, the combatants reached out to the president in April 1905 to mediate. He initially did not want to get involved in the convoluted situation. But by the time Roosevelt arrived in Oyster Bay three months later to start his summer vacation, arrangements had been made for a peace conference at Portsmouth, New Hampshire. The Russian envoys were Sergei Witte, president of the council of ministers, and Baron Rosen, ambassador to the United States. The Japanese representatives were Minister of Foreign Affairs Baron Komura and the minister to the United States, Kogoro Takahira. Baron Kentaro Kaneko, who had attended Harvard at the same time as TR but had not met the future president then, was a third envoy with no official role in the negotiations. TR liked the intelligent Kaneko and invited him to Sagamore, where they walked and swam and had dinner with Edith and seven-year-old Quentin. The boy was sent to bed after dinner while the adults remained in the library talking. At 9:30 p.m., the First Lady folded her knitting and said, "I am going to bed but I don't expect you to follow until you have straightened out the affairs of the world." She provided two candles and a box of matches and said, "Light yourselves to bed, gentlemen and good night." TR and his guest talked for another hour and a half before the president locked the windows, blew out the lamp and put the dog out. The men headed upstairs to sleep, though not before the president gave his guest extra blankets. Witte came to Sagamore Hill a month later with a letter from the czar and told the president that the Russians were willing to negotiate based on the Japanese victories to date but not concede that they might lose more territories if the fighting continued. The Japanese wanted payment of an indemnity, which the Russians would not accept. The president pointed out that the Russian position was weak and the country might have to pay the Japanese to end the war.[117]

On August 5, the envoys converged on Oyster Bay Harbor. Roosevelt traveled out on a launch from *Sylph* as the Japanese envoys arrived on USS *Tacoma* and the Russians on USS *Chattanooga*. TR brought the delegations together for their first meeting on the presidential yacht *Mayflower* as a

Archie Roosevelt with Josiah the badger, circa 1903. *Courtesy of the National Park Service, Sagamore Hill National Historic Site.*

twenty-one-gun salute sounded while Edith and the children watched from Cooper's Bluff. After TR left to another twenty-one-gun salute, the envoys steamed for Portsmouth. When ten days of negotiations failed to break the deadlock, Kaneko returned to Sagamore Hill. The president told him Japan's insistence on an indemnity was hurting Japan's case in public opinion. TR summoned Baron Rosen, and the two talked during breaks in the president's tennis match. The next day, Roosevelt's suggestion that Japan allow Russia to buy back half of Sakhalin Island was rejected. Kaneko came back to Oyster Bay and was again urged to give up the indemnity. The president was running out of patience, writing to a friend later that "there were moments when I wished I could get the entire Russian government to

the top of Cooper's Bluff and run them violently down a steep place into the sea." The president decided to send a cable directly to the czar and a final appeal to the Japanese emperor via Kaneko.[118]

With an end to the Russo-Japanese War still unrealized, TR made headlines and shocked editorial writers by heading out into the harbor on a wet, gusty day to visit USS *Plunger*, one of the navy's six submarines. The vessel's commander, Lieutenant Charles F. Nelson, assumed the president would examine his vessel from the surface but should have known better. The commander-in-chief had ordered the craft to come from Newport, Rhode Island, because he wanted to see its capabilities, so he squeezed through the eighteen-inch hatch and down the ladder. The captain took the vessel out into the sound and offered a tour. The submarine submerged to the bottom and then rose a minute later before submerging at a forty-five-degree angle and then rising at the same pitch. Roosevelt then took the controls to put *Plunger* through a series of maneuvers. After three hours, TR climbed out of the hatch and remarked, "I've had many a splendid day's fun in my life, but I can't remember ever having crowded so much of it into such a few hours."[119]

Later that same crowded day, with the peace conference in danger of self-destructing, the president cabled Kaiser Wilhelm of Germany, asking him to pressure the czar to come to a settlement. Shortly thereafter, the telephone rang. Loeb picked it up to learn that the Associated Press was reporting an agreement in Portsmouth. Japan had dropped its demand for an indemnity while Russia had given up its claim to half of Sakhalin Island. TR ran upstairs to tell his wife. Then he came down and remarked to lunch guest Herbert Parsons, a New York congressman, "It's a mighty good thing for Russia and a mighty good thing for Japan. And a mighty good thing for me too!" The president, who thumped his chest for emphasis, had read the situation accurately. He would be awarded the Nobel Peace Prize for his mediation, becoming America's first Nobel recipient. Komura thanked Roosevelt with an ancient samurai sword that is now displayed in the Old Orchard Museum at Sagamore Hill.[120]

Roosevelt's presence in Oyster Bay attracted many journalists. There were so many newsmen in the press corps that the president quickly established a system to manage the scrum. He prohibited them from showing up uninvited. On routine days, TR would allow two or three to come, leaving it up to the writers to decide who it would be. Only on days with major news announcements would he invite the whole gaggle up to the house.[121]

Quentin Roosevelt hunting June bugs in the daisies, 1904. *Courtesy of the National Park Service, Sagamore Hill National Historic Site.*

The newsmen were interested in all of the Roosevelts. Reporters looking for stories often tried to get something provocative out of the children, who were wise beyond their years. "I see him occasionally, but I know nothing of his family life," Quentin told one journalist asking about his father.[122]

Political cartoonists, for whom TR's appearance, personality and politics had already been a godsend, received a bonus when the president traveled to sleepy Oyster Bay to supposedly relax at Sagamore Hill. The *Chicago Tribune* published a cartoon headlined "The President Is Resting at His Home at Oyster Bay." It consists of six illustrations, captioned, "He first chops down a few trees. Then he has a little canter cross country. After which he takes a brisk stroll of 20 miles. He then gives the children a wheelbarrow ride. And rests a moment or two. By which time he is ready for breakfast."[123]

Much of the coverage, particularly in magazine profiles, was glowing. A good example is a 1905 story in the *Country Calendar* that describes Sagamore Hill and its "country gentleman" owner.

> *Those who look for ostentation are doomed to disappointment. . . . There are no liveried lackeys to give artificiality. . . . It is large, and spacious-*

roomed, furnished to excellent taste. Characteristically, the president grabs an axe and heads for the woods. . . . They [TR and the author] walk down the winding steep path to the shore of Cold Spring Harbor to the private swimming beach where rowboats are stored. TR explains his love of rowing: "I like it because it is something Mrs. Roosevelt and I can do together. We take our lunch and two or three boats. I row down to Lloyd's Neck, where there is a portage, and we spend the day in Lloyd's Harbor. In all, it gives me a fifteen-mile row and some good exercise . . ." On the way back to the house the President vaults the fence, in order to see how the haying is progressing. . . . In Mrs. Roosevelt's flower garden the gentle side of the man blossoms out, and, as he stops to pet his dogs, there is a passing glimpse of his love for animals. It is the only rest—and momentary at that—before he hastens away to play tennis with his sons.[124]

Broadway magazine was similarly worshipful and even more over-the-top in a 1907 cover story on TR returning to Oyster Bay for his annual summer vacation, illustrated with a painting of TR holding a hay rake:

In the Roosevelt lexicon there is no such [thing] as rest. When he honestly tries to rest he ricochets. . . . There he goes flashing past on cantering Blenheim. . . . Or there he is on the hillside in front of his house, his throat bared, his arms bared, his brow wet, bending and rising in the glaring sun—pitching hay! Or he is out back of the house, superintending the painting of the barn. Or on hands and knees examining the progress of his asparagus beds, moving slowly with a knowing eye through the rows of corn. Or he is scampering, running and battling on the tennis court. Or out in a heavy boat manning the oars, with a smiling family and two big picnic hampers for cargo, on a four-mile pull to Lloyd's Neck. Or the hammer and crackle of his blade is heard as he fells trees.

The author describes the president as "a tall, broad figure of a man . . . His face was tanned the color of a new football. He looked superbly big and rugged, and capable."[125]

The *Farm Journal* came in 1906 to examine the agricultural aspects of the property and left seduced:

Turning into the President's private driveway which opens on to the public road, I looked up and saw an unpretentious white board nailed to a tree at the entrance, with the wording, "Sagamore Hill," in modest small black

Cover of *Broadway* magazine in 1907 depicting President Theodore Roosevelt vacationing at the Summer White House in Cove Neck. *Courtesy of the National Park Service, Sagamore Hill National Historic Site.*

letters. There was no gate, no guardian fences, no fuss, no citified style. Just a plain farm driveway, winding up a wooded slope. Presently the house came into view—a rambling, comfortable-looking old-fashioned structure, with gables, porches and chimneys galore.

The author spent a lot of time with farm manager Noah Seaman, who told him, "We keep, usually, about five horses, six cows, eight pigs and a flock of Barred Plymouth Rock chickens. Some turkeys, too. All the hay and straw needed for our stock are grown on the place." Stable manure was the only fertilizer used. Gas to light the house was made on the property from gasoline.

As for Roosevelt, Seaman said, "The President is very fond of chopping. Nearly every day when he is here, he takes his axes, chops down a tree, and then cuts it up into firewood or fence material." As another example of TR liking to get his hands dirty, Seaman recalled that the previous July he asked the president if he could help getting in the hay. When it began to rain, Seaman said he called Roosevelt to let him skip the work, but TR "cheerfully responded and was quickly in the field, pitchfork in hand." When Edith sensed Theodore had too much energy to burn, she would conspire with Seaman. He would tell TR the farm crew was short-handed so the president would spend the day chopping trees, pitching hay and doing other chores with the farm employees.[126]

With so many visitors coming, the Roosevelts decided they needed to expand the house to create a bigger space with more dignity than the library or drawing room for receiving important guests. They also wanted to replace the crowded front hall as the family living room.

TR hired an old friend, architect C. Grant La Farge, to design the trophy room, usually referred to by the family as the North Room, in 1905. Theodore and Edith had definite ideas of what they did and did not want in the addition. They rejected La Farge's suggestion for a skylight, with the president stating, "It might be more care than it was worth." They offered minor revisions to his fireplace design and loved his bay windows. Ionic capitals set in pairs against the walls gave the North Room solemnity. A gilded bald eagle carved by Gutzon Borglum, sculptor of Mount Rushmore, was affixed between the tall windows on the north wall. And an alcove on the west side framed by bookshelves provided a view out to the harbor and sunsets. The addition was 1,200 square feet or roughly 30 feet wide and 40 feet deep and set 2 steps below the level of the rest of the first floor. The cost to have John V. Schaefer Jr. & Co. build the room, reconfigure the piazza to accommodate it, add a bathroom off

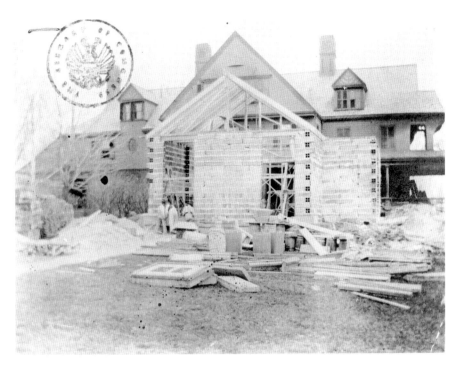

The North Room under construction in 1905. *Courtesy of the Library of Congress.*

TR's dressing room and convert the linen closet next to the boys' room into a bathroom was $19,000.[127]

The summer day that the president arrived from Washington to see the addition, he wrote to the architect:

> *You cannot imagine how delighted I am with the new room . . . the most attractive feature in comfort, in beauty and in dignity, all that could be wished. Really I like it better than any room in the White House which, as you know, is my standard of splendor!*[128]

TR added in a letter to Alice on July 21: "Grant La Farge has done more than I had any idea he could do. It . . . gives distinction to the house. The children have had great dances there for their friends."[129]

Roosevelt moved his favorite hunting trophies into the new space: buffalo heads from the Gun Room and the front hall to sit on either side of the new fireplace. Elk antlers were mounted on the opposite wall to support his Rough Rider sword, hat and revolver. The pistol had been presented to TR after it was recovered from the sunken battleship USS

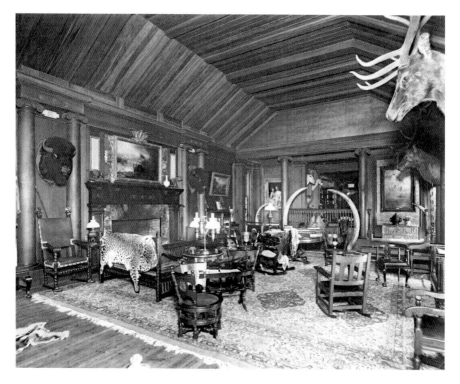

The North Room, circa 1914. *Courtesy of the National Park Service, Sagamore Hill National Historic Site.*

Maine in Havana Harbor. (It was later displayed in Old Orchard, where it was stolen twice and recovered each time, most recently in 2006, after having been missing for sixteen years.)[130]

Ted reminisced:

> *The North Room to me always means evening, a great fire blazing on the hearth. . . . Father, a book under one arm, poking it with a long iron trident, Mother sitting sewing in a corner of the sofa by a lamp.*[131]

There were other alterations to the house and grounds between 1904 and 1910. Three bathrooms were added by building additions to the second floor, and TR got his own "splash closet," or shower.[132]

Writing to Ted in the fall of 1903, TR said, "The old barn I am sorry to say, seems to be giving way at one end." It appears to have been demolished or collapsed within a year of the letter. (Its foundation stones remain along the southern property line.)[133]

The Roosevelts immediately began planning for a replacement barn. The initial drawings were too grandiose and expensive for Edith, who wrote to Noah Seaman: "I do not care to build anything so elaborate. . . . As long as I have a stable, such a barn would be more than we need. I want a barn like the old barn without any cellar" to reduce the expense of concrete foundations. The New Barn was built 420 feet northeast of the main house, near the center of the property and close to the Stable and Lodge in 1907. The wood-framed structure measured thirty-two feet by forty-two feet and had a gambrel roof with a cupola for ventilation. It was accessed through large sliding doors on the sides. A small herd of dairy cows shown in historic photographs was most likely housed in the barn with the carriage horses. Edith Roosevelt's account books show an entry under plumber and carpenter in October 1907 for $2,265, which was probably for the barn.[134]

A small raised shelter with a shingle roof, framed in wisteria and named the Nest was built near the western boundary of the property two hundred yards north of the house in or after 1906. When Edith, who suffered from neuralgia, needed to recuperate and take a break from the hectic activity of managing the house and family, she found escape by reading, sewing or viewing the water at the Nest.[135]

Initially, access to the property was via a dirt carriage road that led to the porte-cochère and by a dirt service road to the north. By 1905, an extension of the entrance road carried it around the east side of the house to connect with the service road on the northeast corner of the property. Because early automobiles could not make the grade of the entrance road, drivers took the service road. But the Roosevelts did not want visitors passing the working farm outbuildings, tennis court and the part of the piazza where they sat. So, in 1911, they planned a new road that in part would run on W. Emlen Roosevelt's land with his permission. It would veer farther east into the woods than the existing main access road to give a more rustic appearance and privacy. In the spring of 1912, engineer Hans Rude Jacobsen, who had worked for Emlen and suggested the new route, completed a macadam roadway. It swung onto Emlen's land southwest of the original entrance road, eliminating switchbacks.[136]

In 1908, Roosevelt declined the nomination to run for a second full term as president. His handpicked successor, William Howard Taft, won the election—an outcome TR would come to regret.

As the end of his presidency approached, TR wrote to Kermit that while both he and Edith enjoyed Washington, "Sagamore is our home. It is Sagamore that we love; and while we enjoy to the full the White House,

The gardens with Stable and Lodge in the background in July 1905. *Courtesy of the National Park Service, Sagamore Hill National Historic Site.*

and appreciate immensely what a privilege it is to be here, we shall have no regrets when we leave."[137]

Despite assurances to himself and others, Theodore Roosevelt would miss being president and would try again to fill the position. But he was also proficient at keeping himself busy even if he was not running the country. And Sagamore Hill would figure prominently in his post–White House future.

5
The Post-Presidential Years

Theodore Roosevelt knew himself well enough to know that giving up the excitement and power of the White House would be a letdown and he would need something to provide substitute stimulation. So even before his departure from Washington he began planning a hunting trip to Africa with Kermit. TR invited scientists, veteran African hunters and firearms experts to Sagamore Hill to help prepare for his specimen-collection expedition on behalf of the Smithsonian Institution.[138]

Roosevelt departed the capital on March 4, 1909, for Cove Neck. He arrived that evening to find Ethel had prepared the house with fireplaces aglow.[139] He wrote Bamie five days later:

> We could not have had a pleasanter homecoming. I wanted to be here in late Winter [when] at night under the full moon the snow-covered landscape is beautiful beyond description. . . . I am dictating this in the North Room, with the big logs blazing in the hearth. So lovely is it that I am utterly unable to miss the White House, and though I miss very much the friends that I used to see at the White House, I am very glad to be home.[140]

Even though they now could afford a more ostentatious lifestyle, Theodore and Edith chose to continue living simply. The frugal Roosevelts did purchase their first automobile in 1909 but only acquired a Victrola more than a year later.[141]

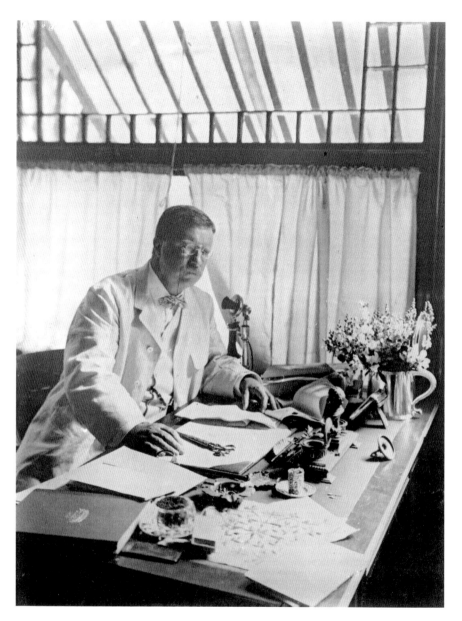

Theodore Roosevelt in the library, 1905. *Courtesy of the National Park Service, Sagamore Hill National Historic Site.*

Three weeks after his homecoming, Roosevelt sailed for Africa. With her husband and Kermit absent and the other sons away at school, Edith seized the opportunity to renovate the house. She arranged for the construction of

two bathrooms next to the South Bedroom and TR's dressing room along with replacing and repairing wallpaper and plaster. Then Edith laid off all the domestic staff, closed up the house and took Ethel to Europe. It was the first summer since Sagamore Hill was built that it was unoccupied. Edith returned home for a few months in the winter of 1909–10 to check on the work before she and Ethel met TR and Kermit in Sudan. The family toured Europe before a tumultuous welcome in New York in June 1910.[142]

On June 20, two days after their return, Ted married Eleanor Butler Alexander in Manhattan. With Alice and Ted gone, life at Sagamore was very different. "This summer has marked the definite end of the old Oyster Bay life that all of you children used to lead," TR wrote Ted.[143] But in the fall, Roosevelt wrote his new daughter-in-law that he was content.

What I now most want is . . . to stay here in my own home with your mother-in-law, to walk and ride with her, and in the evening sit with her before the great wood fire in the north room and hear the wind shrieking outside; to chop trees and read books, and feel that I am justified in not working. I don't want to be in Africa, or on the ranch, or in the Army, or in the White House; I like to think of them all, now and then, but the place I wish to be is just where I am.[144]

The Colonel did not remain secluded at Sagamore for long, however. He soon was busy writing, politicking and exploring. TR had agreed to serve on the editorial staff of the *Outlook* and once or twice a week would go to New York for meetings. Edith relished being back at the house to make more improvements and incorporate the family's acquisitions from the White House years. These included a tiger skin presented by the dowager empress of China and pictures sent by Kaiser Wilhelm. The couple also had to make room for trophies from the African safari such as a Cape Buffalo head that was mounted in the front hall.[145]

Some of the emptiness caused by Alice and Ted marrying and moving out was filled in August 1911 by the birth of the first Roosevelt grandchild, Ted and Eleanor's daughter Grace. Edith marked the occasion by planting little pine trees so the baby would have a place to play when she came to visit. "Mother is preparing the bassinet and the crib and the little bathtub and everything else that was used when all of you were babies," TR wrote to Ted.[146]

The couple's happiness was upset on September 30 when Edith was riding at a gallop with Theodore and Archie along Oyster Bay Cove Road. Pine Knot, her horse named for the presidential retreat in Virginia, shied and

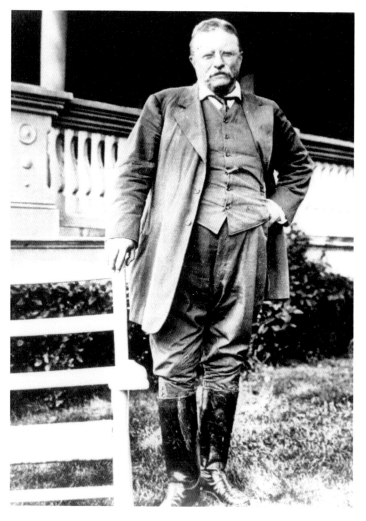

Theodore Roosevelt standing near the piazza, circa 1916. *Courtesy of the National Park Service, Sagamore Hill National Historic Site.*

threw her onto the pavement. Unable to revive her, Theodore flagged down a passing delivery van to transport her to the house. Edith was comatose for thirty-six hours and then for nine days was lucid only periodically. Even after that, she had no recollection of the accident and had lost her senses of taste and smell. She was too weak to venture out of the house for many weeks but eventually regained her sense of taste.[147]

The former president still drew a lot of old friends and admirers to Sagamore Hill. And his growing involvement in politics, his fame and many

interests attracted a never-ending stream of new guests. "Father . . . likes the house full of Tom, Dick and Harry, and I can't quite keep up with the pace but toil panting," Edith wrote to Kermit.[148]

One of the guests Edith enjoyed seeing was Archie Butt. The army major had begun working for TR as a military aide in 1908 and was still working in the White House for William Howard Taft. Butt, who died on the *Titanic* when it sank in 1912, described a visit with Theodore and Edith earlier that year. "We went into lunch and had the same simple food as Mrs. Roosevelt always gives her family," Butt wrote. The Colonel told him, "Our menus are a legacy from my Georgian mother. She taught us to have rice twice a day and hominy every morning for breakfast, and we group simple meats and vegetables around it." Butt related a humorous anecdote:

> *It seems that the telephone had been out of order, and word had been sent to the office to have it repaired. Just before luncheon was over the colored man, one of those who preferred to work for the Roosevelts in private life than to remain at the White House, said:* "Colonel, the telephone man has been here, sir, and he says you cut down all the trees this morning which had the wires on them, and he said too, sir, that you didn't even pull the wires out after the trees fell." *The Colonel looked guilty as Mrs. Roosevelt began to laugh, but he stopped her quickly by saying:* "Now, Edie, don't you say a word. It was your own fault. You always mark the trees I am to cut down, and you did not do it."

After lunch, the guests moved to the North Room and gathered around the fire.

> *We lighted cigars . . .* [and] *continued to smoke and listen to the Colonel for at least two hours. You know, he does most of the talking when he gets started. . . . The Colonel jumped from subject to subject with the agility of a flying squirrel.*[149]

As Butt noted, the Roosevelts brought some of the White House staff back to Cove Neck with them. Edith and Theodore were considered good employers, and when they left Washington the servants vied to continue working for them, even though it meant taking a pay cut.[150]

Among the servants who made the transition with the family was James Amos, who began working for the Roosevelts early in their White House tenure. Initially, he helped take care of the children but eventually spent most of his time attending to TR. Soon after going to work for the White House

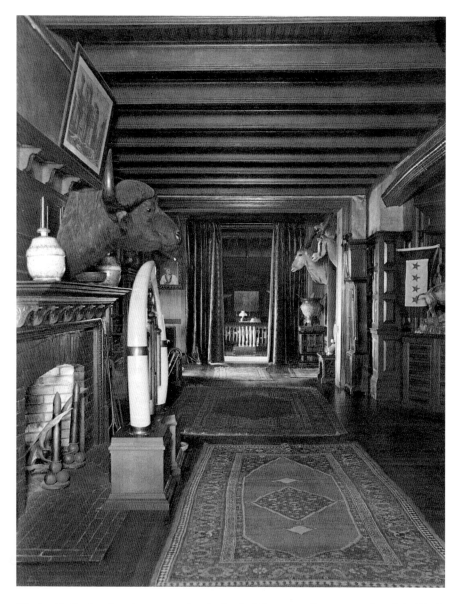

The front hall, when it no longer served as the family living room after construction of the North Room, in 1918. *Courtesy of the National Park Service, Sagamore Hill National Historic Site.*

he was asked to take charge of Sagamore Hill for the summer, probably in 1902. In 1909, TR got Amos, who needed to earn more money, a job at the customs house in New York. But after a year there he came to work and live at Sagamore as the "head man" and TR's valet until he left around

1913 to take a higher-paying job with a detective agency. Amos returned to Cove Neck before TR died. (Later he went to work for the Bureau of Investigation, which became the FBI.) Amos's wife, Annie, whom he had married in 1909, also worked at Sagamore.[151]

The Roosevelts constructed a cottage in 1910 to house the families of Amos and coachman Charles Lee, who was also black. The structure—twenty-six feet by twenty feet and two-and-a-half stories tall—is situated eight hundred feet southeast of the main house near the ravine leading to Cold Spring Harbor. The Roosevelts never named it, but in the 1940s, it was referred to as the Chauffeurs Cottage, then Grey Cottage in the 1960s and later Gray Cottage. (It now houses National Park Service employees.)[152]

Most of the female servants lived on the third floor of the main house while most of the male servants lived upstairs in the stable or off the property.[153]

The 1910 census listed Theodore and Edith, four of their children and eight servants at Sagamore Hill. Besides Amos, thirty-two, who is listed as a messenger; his wife, twenty-six; and Lee, thirty-six, also listed as a messenger, there was Lee's wife, Clara, thirty-five, who worked intermittently as a chambermaid and later did housework; Mary Sweeney, a twenty-two-year-old single housemaid from Ireland; forty-eight-year-old cook Meta Bat, a German immigrant with one child; waitress and single Irish immigrant Catherine Daley, thirty-five; and Arthur Williams, an eighteen-year-old black butler, who was single.[154]

Edith's interaction with Amos reinforces the image of her as an employer who did not miss much. Ethel recalled that Amos's duties included dusting part of the house weekly, and when he forgot to do it, her mother would write his name in the dust as a quiet but embarrassing reprimand.[155]

Back in Cove Neck full time, Roosevelt resumed his customary activities. Amos wrote, "I am sure he was never so happy as when he was out in the grounds of his estate with an axe in his hands chopping down a tree or building a fence." The Colonel kept seven axes by the front door, using each for a day before having the superintendent sharpen them. He continued his study of nature. In 1910, TR made a list of all the birds he saw or heard around Sagamore Hill. There were forty-two, ranging from a little green heron to a screech owl.[156]

TR described Sagamore and his life there in a 1913 article in the *Outlook*.

> *At Sagamore Hill we love a great many things—birds and trees and books, and all things beautiful, and horses and rifles and children and hard work and the joy of life. We have great fireplaces, and in them the logs roar and*

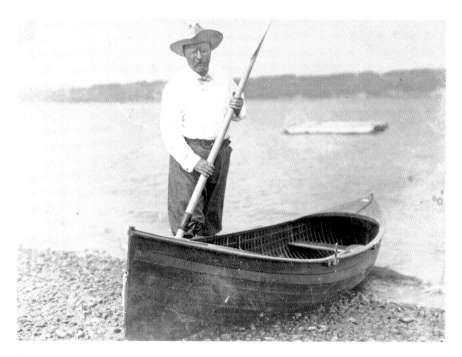

Theodore Roosevelt with rowboat on the shore at Sagamore Hill. Rowing was one of his favorite pastimes. *Houghton Library, Harvard University 560.52 1905-153.*

crackle during the long winter evenings. The big piazza is for the hot, still afternoons of summer.

Roosevelt elaborated poetically:

Many birds dwell in the trees round the house or in the pastures and woods nearby, and of course in winter gulls, loons and wild fowl frequent the waters of the bay and the Sound. We love all the seasons; the snows and bare woods of winter; the rush of growing things and the blossom-spray of spring; the yellow grain, the ripening fruits and tasselled corn, and the deep, leafy shades that are heralded by 'the green dance of summer;' and the sharp fall winds that tear the brilliant banners with which the trees greet the dying year.

The water remained a major attraction:

The Sound is always lovely. In the summer nights we watch it from the piazza, and see the lights of the tall Fall River boats as they steam steadily

by. Now and then we spend the day on it, two of us together in the light rowing skiff, or perhaps with one of the boys to pull an extra pair of oars; we land for lunch at noon under wind-beaten oaks on the edge of a low bluff, or among the wild plum bushes on a spit of white sand, while the sails of the coasting schooners gleam in the sunlight, and the tolling of the bell-buoy comes landward across the waters.

And Roosevelt listed "our most cherished possessions":

A Remington bronze, "The Bronco Buster," given me by my men when the regiment was mustered out, and a big Tiffany silver vase given to Mrs. Roosevelt by the enlisted men of the battleship Louisiana *after we returned from a cruise on that vessel to Panama . . . There are various bronzes in the house: Saint-Gaudens's "Puritan," a token from my staff officers when I was Governor; Proctor's cougar, the gift of the Tennis Cabinet* [a group that started out playing the sport with the president but then expanded to what Roosevelt called "rough, cross-country walks"]. . . . *Mixed with all of these are gifts from varied sources, ranging from a brazen Buddha sent me by the Dalai Lama and a wonderful psalter* [a volume containing the Book of Psalms] *from the Emperor Menelik to a priceless ancient Samurai sword coming from Japan in remembrance of the peace of Portsmouth, and a beautifully inlaid miniature suit of Japanese armor given me by a favorite hero of mine, Admiral Togo, when he visited Sagamore Hill. There are things from European friends; a mosaic picture of Pope Leo XIII in his garden . . . a Viking cup; the state sword of a Uganda king. . . . Then there are things from home friends: the polar bear skin from Peary; a Sioux buffalo robe with on it, painted by some long-dead Sioux artist, the picture story of Custer's fight; a bronze portrait plaque of Joel Chandler Harris; the candlestick used in sealing the Treaty of Portsmouth. . . . There is a picture of a bull moose by Carl Rungius, which seems to me as spirited an animal painting as I have ever seen.*

Ever the bibliophile, Roosevelt noted that "the books are everywhere."[157]

Since Sagamore was still an active farm, Edith conferred daily with the superintendent about the production of eggs and other matters. Some assumed the property was a financially profitable agricultural venture. But TR wrote in 1918, "We try to make the place partially (sometimes very partially) self-supporting. . . . We raise vegetables, fruits, chickens, eggs, milk

and pork for our own use; and hay and corn for the cows and horses. We sometimes sell hay, corn, potatoes or apples."[158]

While TR loved "a great many things" about his post-presidential life at Sagamore, he did not stop thinking about politics. Since Taft had replaced him, Roosevelt felt increasingly that the president was siding with the conservatives in the GOP and repudiating TR's progressive legacy. In 1912, the Colonel broke openly with his successor. With Republican regulars sure to renominate Taft, a movement was growing for a third party with Roosevelt at its head. In July, TR convened a family conference at Sagamore. He wanted to run but knew that creating a split in the party would have repercussions for the family, especially Alice, as the wife of a Republican congressman. Edith, Ethel, Kermit, Archie and Quentin were unanimous in supporting a campaign. "My public career will probably come to a close on Election Day," TR predicted to E.A. Van Valkenberg, publisher of Philadelphia's *North American*, when he visited the house the next day. "But I've got to make the fight. . . . If I don't run, everything I've stood for, and tried to advance politically, will be lost." The new Progressive Party—nicknamed the Bull Moose Party after TR said he felt as healthy as that animal—nominated Roosevelt at its convention in Chicago with TR and Edith in attendance. While the party headquarters was in Manhattan, there were numerous strategy sessions at Sagamore.[159]

Edith and Theodore were thrilled when their daughter-in-law brought Gracie to Cove Neck for the summer. Eleanor was unprepared for round-the-clock exposure to the Roosevelt lifestyle. As an only child, she had been pampered and somewhat isolated. At Sagamore, she wrote more than a decade later, "Something was going on every minute of the day. The house was always full of people. . . . The telephone never stopped ringing." She thought, wrongly, that things would quiet down at night:

> *The Roosevelt family enjoyed life far too much to be willing to waste time sleeping. Every night they stay downstairs until midnight; then, talking at the tops of their voices, they trooped up the wide, uncarpeted oak staircase and went to their rooms. For a brief 10 minutes all was still; and just as I was dropping off to sleep for the second time, they remember things they had forgotten to tell each other and rushed shouting through the halls. I used to go to bed with cotton in my ears, but it never did any good.*

At first, Eleanor found some solace in thinking that at least the family might sleep late. But by 7:00 a.m. she realized, "I was the only one who is not joyously beginning the day."

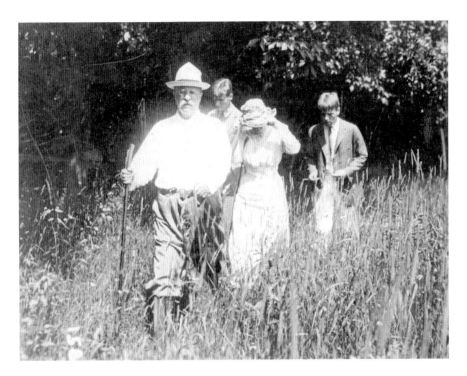

Theodore Roosevelt leads his wife, Edith, and sons Archie, on the left, and Quentin on a hike at Sagamore Hill in a 1916 photograph from a family scrapbook. *Courtesy of the National Park Service, Sagamore Hill National Historic Site.*

Ted's wife soon endured her first picnic Sagamore Hill style. TR suggested one at breakfast on a "boiling hot day." His daughter-in-law responded enthusiastically, imagining a variety of delectable foods eaten in the shade. The reality turned out to be far different. The menu was clams and ham sandwiches. The group marched through the woods and down to the beach at a pace that left Eleanor breathless, braved a cloud of mosquitoes and then took their places in five rowboats. "Under the blazing sun, we rowed and rowed. There was not a vestige of breeze . . . Some two hours later, we landed on a beach precisely like the one from which we had started . . . There was not the least shade." Roosevelt offered her the first cooked clam. "At first, although gritty with sand, it was delicious; but that soon wore off and it became like a piece of old rubber hose." By the end of the summer, Eleanor had learned to sleep under all circumstances and was twenty-six pounds lighter from all the exercise.[160]

When not in Oyster Bay, TR was campaigning to regain the White House. He was in Milwaukee, Wisconsin, to give a speech on October

14. As he was leaving his hotel and getting into an automobile for the trip to the auditorium, John Schrank, a deranged former New York City saloonkeeper, rushed forward and shot him in the chest. His folded speech and eyeglass case absorbed some of the force, but Roosevelt, seriously wounded, insisted on giving his address before seeking medical attention. Edith rushed to Chicago, where her husband was being treated. A week later, they returned to Oyster Bay, where Amos kept watch over him. After one night's rest, TR protested against such "mollycoddling," but he agreed to remain in the house for three days at Edith's insistence and then went out to walk the grounds on his birthday, October 27, despite her displeasure. The next day, his wife allowed TR to meet with the press in the drawing room, where, despite the doctor's instructions to the contrary, he shook everyone's hands vigorously. The reporters noted that the Colonel appeared as if he had never been injured. Asked how it felt to still have the bullet in him, Roosevelt replied, "It feels like rheumatism, only a lot worse."[161]

On Election Day, with Roosevelt and Taft splitting the Republican vote, Democratic nominee Woodrow Wilson was elected, as TR and pundits had predicted. Roosevelt did have the satisfaction of outpolling Taft. Just before midnight, reporters crowded into the library for the Colonel's reaction on the Democratic landslide. With his usual energy and equanimity, the reporters noted, TR read a statement: "I accept the result with entire good humor and contentment."[162]

The following winter was quiet, as Roosevelt was no longer campaigning for anything and many of his neighbors and peers treated him as a pariah for turning on the Republican establishment. With just TR, Edith and Ethel at home, they went riding, and Roosevelt agreed to collaborate on a book about African game animals based on his safari. He also pulled himself out of his funk and conviction that his public life was over by beginning work on an autobiography and entertaining leaders of the Progressive Party who came to discuss the future.[163]

Theodore and Edith were soon to have the house to themselves. Ethel informed her parents in February 1913 that she was going to marry Dr. Richard Derby after a very long courtship. The couple was married in April at Christ Church in Oyster Bay, the family's Episcopal place of worship for a quarter century. The wedding breakfast was served in the dining room, North Room and on the piazza with TR and Edith entertaining their special friends in the drawing room. The newlyweds ran out the front door through handfuls of rice and embarked the next day on a steamer to Europe for their honeymoon.[164]

After finishing his autobiography in 1914, TR came up with an adventure that would take his mind off politics and allow him his "last chance to be a boy." But there would be a steep price for being co-commander of an eight-hundred-mile expedition to map the River of Doubt, an Amazon River tributary in Brazil later renamed Rio Roosevelt. Still suffering fevers from his time in Cuba during the Spanish-American War, Roosevelt became so ill during the four-month expedition that he begged Kermit to leave him behind. But his son, who accompanied him at Edith's insistence, refused. TR survived—barely—but his health was never the same.[165]

Quentin's departure for college in 1915 was hard on his parents. "I am a little sad to think that the last of the boys is taken the first step of entrance to the gray world," Edith wrote to Kermit. She thought of getting TR to take them on a trip to distract him but decided against the idea because "he does like his own Sagamore Hill, poor lamb."

Roosevelt supported Henry Cabot Lodge for the Republican nomination in the 1916 presidential election after refusing it for himself. The Republicans nominated Supreme Court justice Charles Evans Hughes instead. The Progressive Party did nominate TR, who declined in a telegram from Oyster Bay. Wilson was elected for a second term.

When World War I had erupted in Europe in 1914, Roosevelt had been convinced the United States would not be able to stay out of it and lobbied for a buildup of American forces and a place in them for himself. Those who agreed with TR on the folly of isolationism gravitated to Sagamore Hill, causing Edith to grumble to Kermit: "I can't quite keep up with the pace."[166]

Ethel and Richard Derby did not wait for the United States to get into the war. They volunteered in 1914 and were assigned to the American Ambulance Hospital in France in the fall. Ethel served as a nurse. She returned home first so she could care for their son, Richard Jr., who had been born in March 1914 and left in the care of Theodore and Edith, and to give birth to daughter Edith in June 1917. Ted's wife, Eleanor, also went to France as the first woman to be sent overseas by the YMCA. She organized canteens for men on leave.

As for TR, the old Rough Rider believed he had one more fight in him. When the United States entered the war in the spring of 1917, Roosevelt traveled to Washington to ask Wilson to allow him to raise a volunteer division to fight in France. TR, who had criticized the president's reticence to intervene in Europe, was rebuffed. Two days later, about twenty of his most active supporters, including several former Rough Riders, such as Seth Bullock, sheriff of Deadwood, South Dakota, and

former secretary of war Henry L. Stimson, gathered in the North Room to mark the end of their planning.[167]

While TR remained on the sidelines, all four of his sons would serve—with dire and in one case tragic consequences. Ted and Archie signed up in the summer of 1917 to serve as officers under the American commander in France, General John J. Pershing, while Kermit secured a staff position with the British in Mesopotamia (now Iraq). Quentin, nineteen, enlisted in the army's air wing and, after his pilot training on Long Island, prepared to ship out for Europe. On the night before his departure, Edith went up to his bedroom as usual to tuck him in; they still enjoyed reading fairytales together.[168]

"They have all gone away from the house on the hill," Edith wrote. In keeping with the custom of other families with sons fighting, the Roosevelts hoisted a flag with four stars—one for each of the boys. Flora Payne Whitney, Quentin's secret fiancée, was a frequent visitor—so much so that his parents soon figured out the young couple's arrangement. With her husband still in France, Ethel shuttered her house in Oyster Bay, and she and their two children moved in with her parents. They and a nursemaid lived in the old nursery rooms on the south side of the house from the summer of 1917 into the summer of 1918.[169]

The beginning of 1918 brought a major change to the house: it was finally wired for electricity, at a cost of $1,552.34. "The electric light has been a convenience, and as yet we are not burned to the ground," Edith wrote Kermit six months later. Nothing, however, was done about the heating system, which never seemed to adequately live up to its name. "Sagamore is just as warm as it ever was in cold weather," Edith wrote to Bamie. "We have plenty of coal but a bird cage is hard to heat."[170]

The war created a manpower shortage for those looking to hire or retain servants. Edith complained to Kermit that "the servant question has risen to mountain high difficulties. I can get no waitress in all of New York who is willing to spend a winter at Oyster Bay."[171] But the Roosevelts fared better than most other affluent families. Mary Sweeney, the longest-serving of the Sagamore servants, remained Edith Roosevelt's housekeeper and personal maid for the rest of her employer's life.

Theodore's health continued to decline. Already blind in his left eye from an injury received in 1904 while boxing at the White House, in February 1918, he was admitted to Roosevelt Hospital in New York for surgery on abscesses in his thigh and ears. Inflammation developed in the left inner ear, prompting fears that the Colonel might not survive. But the fever broke and TR went home in early March.[172]

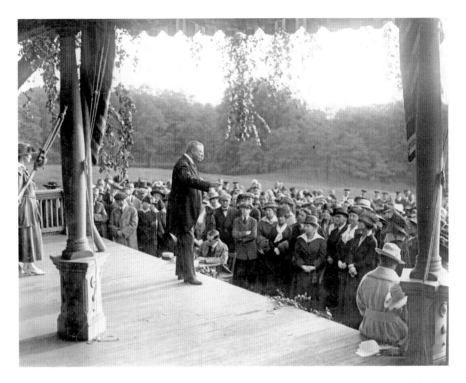

Theodore Roosevelt addressing women's suffrage delegates in 1917. *Courtesy of the National Park Service, Sagamore Hill National Historic Site.*

The Roosevelts continued to fret over the well-being of their four sons, all at or near the front in France or the Middle East. First, Quentin developed a severe case of pneumonia. Then Archie was hit by shrapnel, which injured his left leg and broke an arm. Ted was promoted to lieutenant colonel and decorated for conspicuous gallantry after being gassed, and later, he was wounded in the leg. Kermit, who had received the British Military Cross for gallantry, obtained a discharge so he could join the American forces and was made a captain in an artillery regiment.[173]

For the first time in his crowded life, TR had trouble sleeping. "I wake up in the middle of the night, wondering if the boys are alright [*sic*], and thinking how I could tell their mother if anything happened," he told a friend. Roosevelt made a western speaking trip in June 1918 and returned to Sagamore with a high fever and erysipelas, a skin infection, in his left foot.[174]

In July 1918, Lieutenant Quentin Roosevelt shot down his first German airplane. A delighted TR wrote to Ted that "the last of the lion's brood has been blooded." Ten days later, the Colonel was in the library when

Associated Press reporter Phil Thompson, a friend of the family, came to the house with a censored cablegram sent to the *New York Sun* that read "watch Sagamore Hill for . . ." Asked what it meant, Roosevelt replied, "Something has happened to one of the boys. It can't be Ted or Archie, for both are recovering from wounds. It's not Kermit, since he's not at the moment in the danger-zone so it must be Quentin. His mother must not be told until there is no hope left." Theodore and Edith dressed for dinner as usual and then talked and read as if everything was normal. But Edith must have suspected something was wrong because there is a rare blank page in her diary for that day. Thompson returned the next morning and told Roosevelt on the piazza that he had verification that Quentin's plane had been attacked by two German fighters and shot down behind enemy lines. "But Mrs. Roosevelt!" TR gasped. "How am I going to break it to her?" He went back inside the house and half an hour later handed Thompson a brief statement: "Quentin's mother and I are very glad that he got to the front and had a chance to render some service to his country, and show the stuff that was in him before his fate befell him." Edith emerged a few hours later and, thinking more about her husband than herself, said to Thompson, "We must do everything we can to help him. The burden must not rest entirely on his shoulders."[175]

Only two days later, Roosevelt fulfilled his promise to give the keynote address at the New York State Republican convention in Saratoga. To mitigate their grief, TR took Edith for two weeks to Maine, where Ethel and her children were spending the summer. When they returned to Cove Neck, Alice was waiting to help them get through reading Quentin's last letters from France. The mood was brightened by word that Archie was on his way home. He arrived early in September and got to see his five-month-old baby for the first time as a beaming TR looked on from the piazza.[176]

To help cope with Quentin's death, once a week his parents invited twenty enlisted men from nearby Camp Mills in Mineola to come to Sagamore. Edith described the regimen to Kermit: "Father makes a little talk to them in the North Room about his flags and trophies, then I take them to the dining room and give them tea and cake and cigarettes and sometimes we walk to the garden."[177]

TR entered his sixth decade while enduring crippling attacks of rheumatism compounded by the continuing grief over the loss of his youngest child. "Quentin's death shook him greatly," Edith told Kermit in an October 29, 1918 letter. "I can see how constantly he thinks of him . . . Sad thoughts of what Quentin would've counted for in the future."[178]

By early November, one of TR's feet was so swollen he could not wear a shoe. Three physicians came to Sagamore and ordered him to rest in

bed. He overrode them to vote on November 5 and felt even worse. Six days later, he returned to Roosevelt Hospital for treatment of inflammatory rheumatism contracted in Brazil and the abscesses. Edith remained at his hospital bedside for forty-four days.[179]

Roosevelt was able to return home on Christmas Day, although he was still weak and suffering from vertigo from inflammation in the inner ear. Alice, Ethel and Archie were waiting for their parents with Christmas dinner. In the following days, TR ate breakfast in bed, came downstairs for lunch and then lay on the sofa in the library, reading and dictating letters. On December 29 and 30, Edith took her husband for an hour's drive, and he seemed to improve. But rainy weather on New Year's Day 1919 again gave him severe pain in his leg and hand. He began to spend most of his time upstairs lying on the sofa in the Gate Room, the old nursery that faced south and the warmest space in the house.[180]

On the first Sunday in January, the fifth, Roosevelt remained in bed reading aloud to his wife or listening while she read, writing to Kermit or just relaxing with Edith. Flora visited. TR worked for eleven hours on a magazine article and newspaper editorial. Friends came to the house, but the Colonel was too weak to

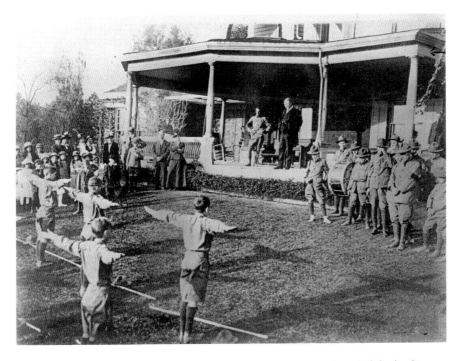

Colonel Roosevelt reviews Boy Scouts, circa 1918. *Courtesy of the National Park Service, Sagamore Hill National Historic Site.*

see them. Edith wrote to Ted several days later: "Father was in your old nursery and loved the view, of which he spoke, and as it got dusk he watched the dancing waves and spoke of the happiness of being home, and made little plans for me. . . . He was very sweet all day. Since Quentin was killed he has been sad, only Ethel's little girl had the power to make him merry."[181]

Edith had finished playing solitaire at the table beside TR's bed and was about to leave when he reportedly looked at her and inquired, "I wonder if you will ever know how I love Sagamore Hill."[182]

Around 10:00 p.m., TR asked his wife to help him sit up because he felt as if his heart or lungs were about to stop working. Edith called for the nurse, who said his pulse was good, but she still sent for a local doctor, who reported the same results. The nurse gave him morphine so he could sleep through the night. About midnight James Amos arrived to help watch Roosevelt during the night and helped put him to bed in the Gate Room. Amos turned off the light and napped in front of the fire. Edith went in to look at her husband twice around 12:30 a.m. and 2:00 a.m. At 4:00 a.m., the nurse woke Edith in her room because TR had stopped breathing. Rushing to her husband of thirty-two years, she leaned over him and called, "Theodore, darling!" Edith wrote in her diary that he "had a sweet, sound sleep." She wrote Kermit that he seemed "just asleep, only he could not hear."[183]

Theodore Roosevelt had died from an embolism on January 6, 1919, at the age of sixty. At 6:00 a.m., Edith telephoned Corinne and told her what had happened. TR's younger sister came to Sagamore late that afternoon and the two old friends walked along the shore and in the woods. When they returned to the house at twilight, it was being circled by low-flying airplanes that Edith surmised must have been dispatched from the camp where Quentin had trained as a guard of honor. Archie cabled his brothers with a terse message: "The old lion is dead."[184]

Roosevelt's coffin, draped with Rough Rider flags, lay in the North Room before his funeral on January 8. Quentin's favorite prayer was read, and the cortège headed to Christ Church, where five hundred mourners waited. Following the custom of the era for widows, Edith remained behind with her daughters and other Roosevelt women to read through the prayers that would be offered at the church.

After the service, the procession began to head east back toward Cove Neck but stopped at Youngs Memorial Cemetery in Oyster Bay Cove. There the twenty-sixth president was buried twenty-six steps up the hillside, a short distance from his beloved Sagamore Hill.[185]

6

Edith Roosevelt on Her Own

Two days after her husband's funeral, Edith closed Sagamore Hill and went to stay with Bamie in Connecticut. Six days later, she sailed for Europe with a maid. When she disembarked in New York on May 15, 1919, all of her children were waiting on the pier to assist in her return to Cove Neck.[186]

Edith had decided that the only reason for her to retain Sagamore was to provide "a centre for the family," she wrote to Kermit. "I am only justified in keeping that house open if I can make it a home for all of you," she told him in a follow-up letter.[187]

Edith Roosevelt would outlive her husband by twenty-nine years and spend all of that time providing "a centre for the family" in Cove Neck. The children, grandchildren and other relatives helped fill the huge void in her life. But her first summer back at the homestead was still so painful that she left her diary blank for two months and then made only occasional entries.[188]

A visit to South America in December 1919 provided an escape from the lonely house. It was the first of many solo winter vacations until Edith became too old and weak to travel. She made a trip around the world with Kermit and visited Ted during his service as governor of Puerto Rico and governor general of the Philippines. After she returned to New York from her first trip on January 17, 1920, the snow over the next two months was so heavy that no one was able to visit and she needed a sleigh to get into Oyster Bay.[189]

Edith Roosevelt on Yagenka in 1904. *Courtesy of the National Park Service, Sagamore Hill National Historic Site.*

When the weather cooperated, not only family and friends but also dignitaries and admirers of the Colonel continued to come to pay their respects to his widow. Among the first was King Albert of Belgium, who was received by Edith in the North Room. On the one-year anniversary of TR's death, a number of his friends made a "pilgrimage" to Sagamore Hill. On the third anniversary, in 1922, Edith led a group of his friends to the grave for the laying of a wreath followed by a gathering in the North Room

Photograph of the garden in Edith Roosevelt's scrapbook. *Houghton Library, Harvard University.*

to read and discuss TR's writings and then lunch. This became an annual event organized by the newly formed Roosevelt Memorial Association (RMA). The pilgrimages, which continued for two decades, could be trying for the hostess. "I worked myself into a state of nerves about the Pilgrimage," she wrote to Ted about the 1929 gathering. She worried about the house being dirty and the grandchildren creating chaos. But she farmed them off to relatives and got the house cleaning done after she did "a noble turn of parlor maid's work & when the pilgrims arrived all was as it should be . . . and I was perfectly content."[190]

Journalists still visited occasionally—but on Edith's more guarded terms than the openness of when her husband was in residence. A writer for *Better Homes and Gardens* came in 1925 for a series titled "Homes of Famous Americans." The author was greeted by Charles Lee, who told him Mrs. Roosevelt was out in the garden, and "no picture is to be taken of the Madame. . . . You cannot go inside the house." Despite the limitations, the writer found much to admire on the property: "The gardens . . . are exceedingly well-kept and have that finish and dignity which can be found associated only with age."[191]

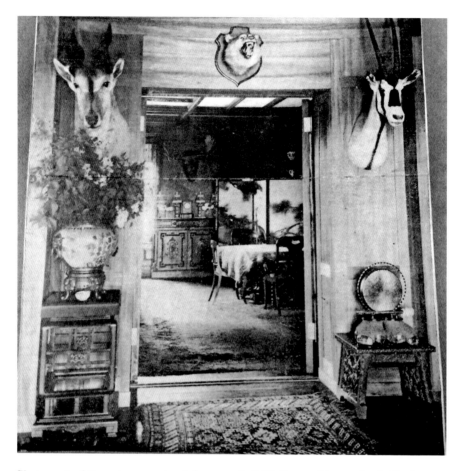

Photograph of the entrance to the dining room in Edith Roosevelt's scrapbook. *Houghton Library, Harvard University.*

The number of pilgrims, journalists and others diminished as the years went on, but her children and fifteen grandchildren kept coming. "It has been such a happiness to have the house full of children once more as Father would have wished," Edith wrote to Ted.[192]

She developed a routine when the grandchildren were there. Edith began the day by reclining on a chaise lounge in her bedroom, polishing her nails before reading or playing solitaire. As the youngsters headed for breakfast, they stopped at her bedside to kiss her on the cheek. After breakfast, she took care of correspondence in the drawing room, usually behind closed doors. Edith spent her afternoons in the garden, wearing a straw hat and carrying a basket for cut flowers. Sometimes she would take the dogs for a walk if it

The piazza, the family's outdoor place to relax and where TR gave speeches. *Copyright Audrey C. Tiernan 2015.*

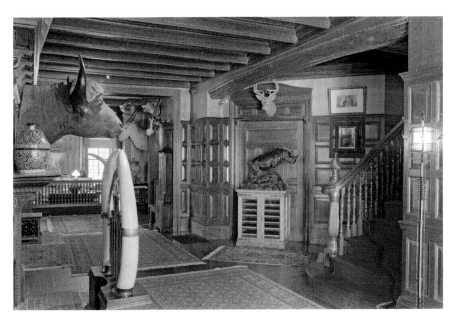

The front hall, which functioned as the Roosevelts' formal living room until the North Room was constructed in 1905. *Copyright Audrey C. Tiernan 2015.*

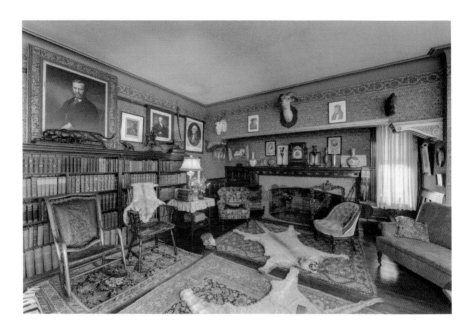

Above: The library
initially served
as an informal
family room until
TR became
governor, when it
became his office.
*Copyright Audrey C.
Tiernan 2015.*

Left: The library
desk. *Copyright
Audrey C. Tiernan
2015.*

The library desk. *Copyright Audrey C. Tiernan 2015.*

The drawing room, the one space in the house that Edith Roosevelt could call her own and decorate to her tastes. *Copyright Audrey C. Tiernan 2015.*

Drawing room sconce. *Copyright Xiomaro.com 2015.*

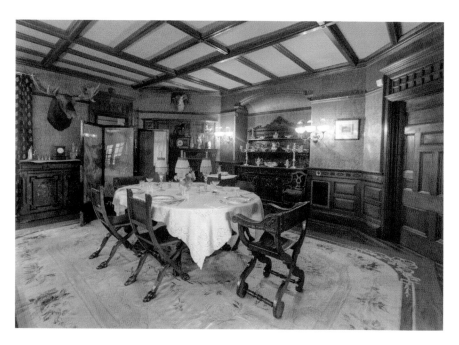

The dining room table, chairs and sideboards purchased by Theodore and Edith Roosevelt during their honeymoon in Italy in 1887. *Copyright Audrey C. Tiernan 2015.*

Edith Roosevelt met with the cook in the kitchen every morning to plan menus. *Copyright Audrey C. Tiernan 2015.*

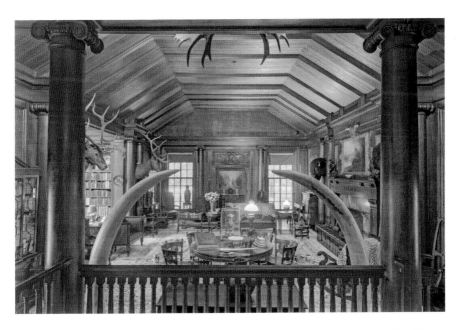

The North Room, constructed in 1905 to receive important guests and serve as a family living area. *Copyright Audrey C. Tiernan 2015.*

The North Room desk. *Copyright Audrey C. Tiernan 2015.*

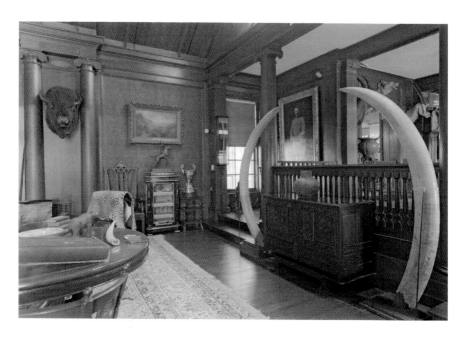

The large elephant tusks at the entryway to the North Room, presented to TR by the emperor of Abyssinia. *Copyright Audrey C. Tiernan 2015.*

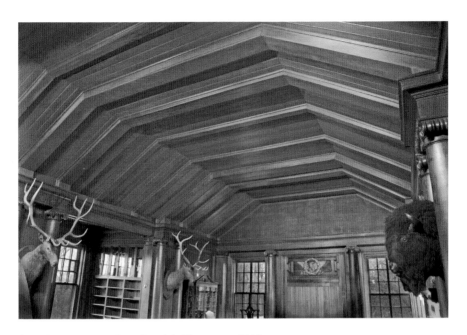

The North Room ceiling. *Copyright Xiomaro.com 2015.*

Gutzon Borglum, sculptor of Mount Rushmore, carved the gilded bald eagle in the North Room. *Copyright Xiomaro.com 2015.*

Colonel Roosevelt's Rough Rider hat and sword from the Spanish-American War displayed on an elk head in the North Room. *Copyright Audrey C. Tiernan 2015.*

Mother's Room was Theodore and Edith Roosevelt's shared bedroom and her private sitting room. *Copyright Xiomaro.com 2015.*

Father's Dressing Room was used by TR from 1885 to 1900 and again from 1906 until his death in 1919. *Copyright Audrey C. Tiernan 2015.*

The Gate Room, the original nursery and where TR died in his sleep early in the morning of January 6, 1919. *Copyright Audrey C. Tiernan 2015.*

The nursery, where babies were bathed and dressed and the young children took naps. *Copyright Audrey C. Tiernan 2015.*

The South Bedroom was used for the care of young children through the 1890s and as Edith Roosevelt's bedroom after her husband's death. *Copyright Audrey C. Tiernan 2015.*

Alice's room was furnished with a bedroom set that belonged to her mother, Alice Hathaway Lee Roosevelt. *Copyright Audrey C. Tiernan 2015.*

The boys' bedroom was shared at various times by all of Theodore and Edith's four sons. *Copyright Audrey C. Tiernan 2015.*

The single guest bedroom, most likely used by visiting relatives. *Copyright Audrey C. Tiernan 2015.*

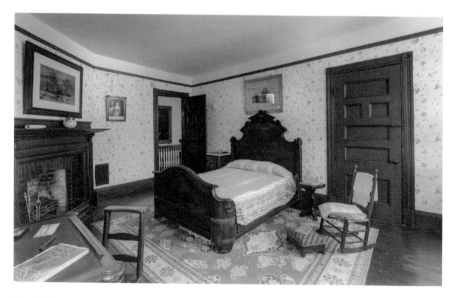

The double guest bedroom, where relatives and close family friends stayed overnight. *Copyright Audrey C. Tiernan 2015.*

Right: The single guest room window.

Below: The Gun Room, used as TR's study and in 1898 and 1901 as a schoolroom.
Both copyright Audrey C. Tiernan 2015.

The Gun Room desk. *Copyright Audrey C. Tiernan 2015.*

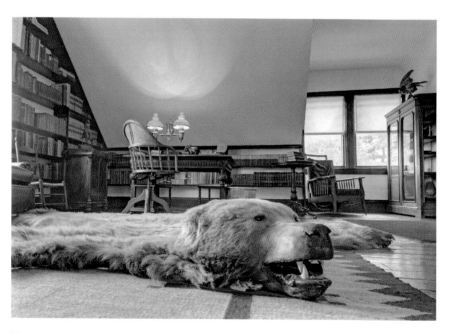

The Gun Room bearskin rug. *Copyright Audrey C. Tiernan 2015.*

Ted's room on the third floor, where he lived starting at age fourteen. *Copyright Audrey C. Tiernan 2015.*

The cooks' room. Two of the cooks each stayed with the family for more than twenty-five years. *Copyright Audrey C. Tiernan 2015.*

The icehouse, built in 1885, was used to store ice cut from nearby ponds. *Copyright Audrey C. Tiernan 2016.*

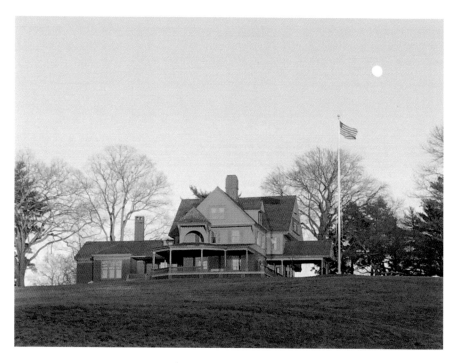

Sagamore Hill at dusk with the moon rising. *Photograph by the author.*

was not too hot. She also swam in the bay waters that she had enjoyed with Theodore. In the evening she sat on the piazza to knit and reminisce.[193]

The family visits were usually considered a welcome distraction. But sometimes, she wrote to sister-in-law Corinne, "an odd feeling of guardianship" persuaded her not to invite some Roosevelt families for fear of "breakings and vanishings" of artifacts she knew were important to preserve for posterity. But even when she looked forward to visits by the children, they left her drained. "I like to see their little faces," she liked to say, "but I prefer to see their backs."[194]

Two of Edith's great-grandchildren who spoke at the reopening of Sagamore Hill in 2015 after a three-year restoration reminisced about what it was like to visit her when they were children. "I remember her being terrifying," recalled Tweed Roosevelt of Boston, Archie's grandson, who grew up not far from Sagamore. "Her views were handed down to my grandparents: 'children are to be seen and not heard.'" And they generally were not even to be seen in the drawing room, which they were told was Edith's private sanctuary. "It was perfectly obvious which part of the house was hers, and we were generally not allowed in there, although we were occasionally allowed in because the great attraction was the bearskin rug."

Theodore Roosevelt IV of Brooklyn recalled his first visit just after World War II. "My mother whispered in my ear 'Remember, children are to be seen and not heard . . .' I said three words to her during that entire visit: 'Hello,' then 'Yes, please' when great-grandmother offered me milk and cookies, and on the way out I remember her saying 'What a nice quiet boy.' My mother beamed because I hadn't disgraced her or myself."

Edith preferred to see the backs of her grandchildren when they were leaving in part because of her reticent personality, but her declining health was also a factor. Edith, sixty-six in 1927, had begun to experience heart problems that curtailed her foreign travel. So she decided to buy an old inn in Brooklyn, Connecticut, that had been owned by an ancestor as a getaway spot. She remained active by supporting the arts and political candidates. She hosted three hundred members of the Edith Kermit Roosevelt Republican Club on August 10, 1932, to celebrate President Herbert Hoover's birthday.[195]

Sagamore Hill continued to operate as a working farm, although not at the same scale as when the Colonel was alive. An inventory of the property after his death shows the barn contained a pair of gray horses, one Holstein cow, two Guernsey cows, a Guernsey heifer, a Guernsey calf, a wagon, various plows and other farm equipment and a sleigh. Along with the cook and maids for the house, Edith retained a farm manager and gardener. When

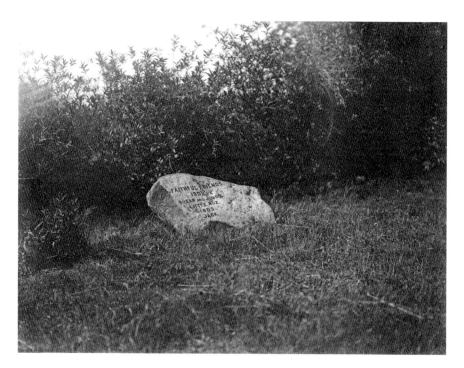

Photograph of the pet cemetery in Edith Roosevelt's scrapbook. *Courtesy of the National Park Service, Sagamore Hill National Historic Site.*

superintendent Robert Gillespie's failing health in the late 1930s prevented him from working, Edith told him, "You have a home here as long as you want." He remained at Sagamore until 1943 and then moved into a house he had built in Syosset.[196]

Charles Lee retired as Edith's chauffeur in 1934 but afterward occasionally still drove her to appointments. He was given a free life tenancy in Gray Cottage until he died on March 4, 1936. Clara Lee, who continued to work at least part time for Mrs. Roosevelt, stayed on at Gray Cottage until her death in 1947.[197]

Edith's health declined further when on the night of November 12, 1935, she got out of bed in the dark to open a window. She fell, fractured her hip and was hospitalized for five months before returning to Cove Neck.[198]

There was an understanding within the family that upon Edith's death Ted and Eleanor would inherit Sagamore Hill. But by 1937, the couple had been living in rented houses for twenty-seven years and decided they could no longer wait. Edith had been asked by the Roosevelt Memorial Association to sell the house so it could become a museum since 1920

Theodore Roosevelt Jr.'s Old Orchard mansion, completed in 1938 and now the museum at Sagamore Hill. *Copyright Audrey C. Tiernan 2015.*

and had always refused, saying it must be kept for Ted and his family. But Eleanor wanted a more modern house, so Ted arranged to acquire four acres that included the apple orchard from his mother in 1938. His architect son-in-law, William McMillan, designed a nineteen-room Georgian mansion constructed by E.W. Howell Company for $90,000. Old Orchard House was finished in April 1938. (It now functions as a museum, staff offices and archives.) Edith liked the new dwelling but was chagrined when her daughter-in-law sent her a bill for $140 for trees to separate the two homesteads.[199]

The construction of Old Orchard was the biggest change on the property during Edith's time there alone, but it was not the only one. Ted erected a wood-shingled cottage for his head groundskeeper north of his house and a six-car garage where the assistant groundskeeper lived. When the Stable and Lodge burned in 1944, the New Barn was altered to become a residence and garage to accommodate displaced caretaker Valenty Mazur, his family and the estate's automobiles around 1947. The windmill was destroyed or dismantled around this time as well. It was replaced by a replica in the early 1970s and another in 2010.[200]

But in the almost three decades that Edith lived in the old house after TR's death, she made few changes to it. She replaced the kitchen range, getting a new double-oven wood and coal range in 1924 to replace the original 1887 model. And some wallpaper and plaster was repaired or replaced. The

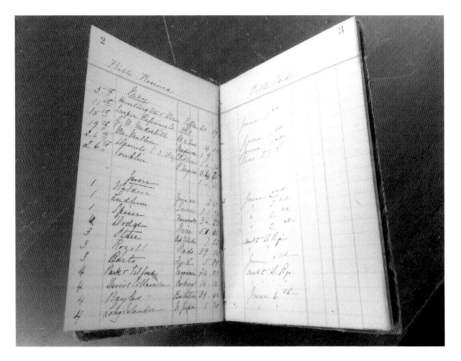

Edith Roosevelt's account book from 1894 to 1903 listing bills received and paid. *Houghton Library, Harvard University.*

retention of the rest of the original structure and furnishings proved a major boon when the house became a museum.[201]

By the time Edith turned eighty, in August 1941, she was troubled by her poor health and Kermit's severe alcoholism. She had grown so mentally and physically frail that she could no longer balance her checkbook or answer her mail.[202]

Kermit, the child most like her, was serving with the army in Alaska during World War II when he committed suicide on June 4, 1943, after a last visit to Sagamore on sick leave. Edith was told that he had died of heart failure.[203]

Her sense of isolation increased on July 11, 1944, when Ted, an army general, died of a heart attack in France after helping to lead the D-day landings the previous month. "Ted's death did something to me from which I shall not recover," Edith told Ethel.[204]

In September 1945, Edith hired an Oyster Bay woman, Jessica Kraft, as her secretary to help write checks and letters. Kraft came in the afternoon and had tea with Edith on her bedroom balcony on nice days or in the North Room.[205]

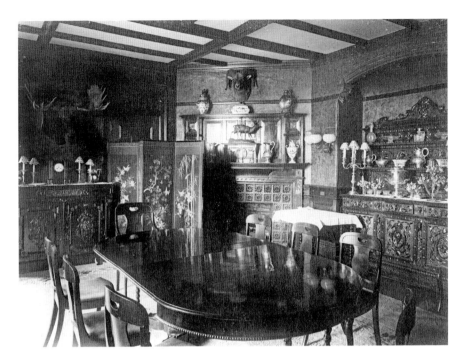

The dining room in 1903. *Courtesy of the National Park Service, Sagamore Hill National Historic Site.*

By 1947, Edith's health had so deteriorated that she was bedridden most of the time. On September 29, 1948, she lapsed into a coma. The next day, at 6:30 a.m., she died at age eighty-seven.

The death of Edith Roosevelt ended the family's time at Sagamore Hill, but it opened the door for the public to experience its wonders.[206]

7
Theodore Roosevelt Association
Saves Sagamore

The idea of transforming Sagamore Hill into a shrine and museum was suggested only days after Theodore Roosevelt's death in 1919. A *Brooklyn Daily Eagle* editorial on January 12 asserted, "There can be no better memorial to him than his own home. There he lived for many years with his family and trophies around him; here he played, thought and planned." It described Sagamore Hill as "redolent of Roosevelt," with every object and every room telling something about the "vibrant personality of the man."[207]

A Sagamore Hill museum was also on the minds of TR's friends who assembled in New York City as the Roosevelt Permanent Memorial National Committee in March 1919. The group believed the Cove Neck property should be "preserved like Mount Vernon and Mr. Lincoln's home in Springfield." That became one of the objectives of the Roosevelt Memorial Association when it was incorporated by Congress on May 31, 1920. (A Women's Roosevelt Memorial Association was created earlier with the goal of rebuilding TR's demolished birthplace in Manhattan.)[208]

In an undated advertisement, the RMA outlined its purpose in preserving the site: "Sagamore Hill is more than the historic home of a great President. It is a symbol of Theodore Roosevelt's conception of the Good Life for the individual and the nation, expressed there in the daily living of an American family, and his own continuous challenge to all that was best in the American character."[209]

When the association approached Edith Roosevelt, she rebuffed the group because its vision for the house conflicted with hers—as her home for the

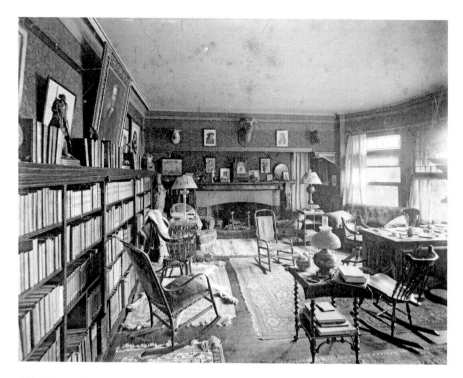

The library, Theodore Roosevelt's office, in 1903. *Courtesy of the National Park Service, Sagamore Hill National Historic Site.*

rest of her life and then the residence of Ted and his family. While telling the RMA she appreciated its interest, Mrs. Roosevelt said having the house continued to be occupied by the family would make it "more vitally a part of American public life than it would as a place of public pilgrimage."[210]

The association moved on to other projects. The RMA controlled nearly $2 million in public donations from a national "Roosevelt Week" fundraising campaign in October 1919. So it spent the next two decades acquiring and dedicating a forty-three-acre memorial park along the southern shore of Oyster Bay, purchasing a ninety-acre island in the Potomac River presented to the nation as a wildlife sanctuary to be known as Theodore Roosevelt Island and accumulating TR's letters and other papers that were donated to Harvard College and the Library of Congress.[211]

Despite Edith Roosevelt's insistence on keeping the house, serious discussions resumed with family members even before her death in the fall of 1948. The completion of Old Orchard in 1938 made it unlikely that Ted and Eleanor would ever live in the old Queen Anne house. The RMA trustees resurrected the subject of a purchase at a meeting in 1940. The

board and its consultants worried that without a sale to the association the property would be subdivided for building lots. But they were told that while Edith Roosevelt expressed great interest in the idea, she still felt the time was not right.[212]

Late in 1947, the RMA received word that the time was right. The executor of TR's estate told the board that the family wanted a sale to be consummated during Edith's lifetime to avoid the complications of dealing with eleven heirs after her death. On March 16, 1948, the executive committee agreed to offer $75,000 for the house, its contents and the property, with Mrs. Roosevelt given a life tenancy.[213]

In May 1948, based on two appraisals, the RMA reached agreement with the family to buy the house and property for $104,000, with the price for the contents to be determined later. But wrangling over the terms prevented the sale from being concluded before Edith Roosevelt died on September 30, 1948. Finally, on April 19, 1949, the association board approved signing a contract with the estate. The document executed on May 11, 1949, stipulated the price of $104,000 for the house and property, with the RMA additionally paying the value of "furniture, works of art and miscellaneous personal property" determined in an appraisal by Parke-Bernet Galleries Inc. the previous fall to be $17,301. The most valuable possession was an eighteen-carat gold presentation cup inscribed "San Francisco Greets President Roosevelt, San Francisco, California, May 12th, 1903," which was valued at $1,500. In the North Room, *The Bronco Buster*, signed by Frederic Remington and inscribed "Colonel Theodore Roosevelt from his Regiment at Camp Wykoff. September 15th, 1898," was appraised at $700. A pair of tusks from an elephant shot by TR in Uganda in 1909 was calculated at $400. On February 10, 1950, the RMA paid $20,220 for all the items in the Parke-Bernet appraisal except for those kept by members of the family.[214]

The *New York Herald Tribune* reported that the RMA expected to spend $500,000 to $750,000 to prepare the house for visitors in about a year. The article quoted Ethel Roosevelt Derby, TR and Edith's younger daughter and a member of the RMA board: "I am pleased not merely for sentimental reasons but because it can serve a useful purpose for inculcating and disseminating Americanism. There are too few such places in our country, and we should do all we can to preserve those we have."[215]

TR's great-grandson Theodore Roosevelt IV praises Ethel as "the unsung hero" of the Sagamore Hill story. As the family was preparing to sell the property, "she was the one who mobilized" the association to make the

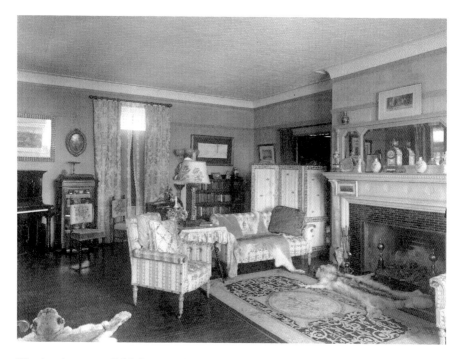

The drawing room, Edith Roosevelt's domain, in 1904. *Courtesy of the National Park Service, Sagamore Hill National Historic Site.*

purchase. "More importantly, she laid down the law to the family: there will be no looting by children or grandchildren of the contents of this house." And that ensured that the house would become a museum with most of its original contents in place.[216]

Ending the protracted process of buying Sagamore Hill did not end the RMA's travails. The association needed the Village of Cove Neck to change its zoning to allow the house to be open for the public. That proved to be a major obstacle. Cove Neck's unwillingness to amend its code delayed the transfer of the title until 1950. Village officials and residents were concerned about altering the entirely residential character of the community and also felt the private two-lane road leading to the property was too narrow to handle the expected traffic.[217]

Nonetheless, in June 1949 the Roosevelt estate and association petitioned for a change of zone. The proposal drew praise from local and New York City newspapers. "The establishment of a national shrine in our community would be a great source of pride to everyone residing in this area," commented the *Oyster Bay Guardian*. The *Herald Tribune* stated that a Sagamore Hill museum would allow visitors to "catch a glimpse of something profoundly important

to their nation's life." Village residents remained unconvinced. At a hearing in July, all but two speakers opposed the change. They cited the narrowness of Cove Neck Road, the loss of tax revenue if the property were owned by a nonprofit group, fears that visitors to Sagamore Hill would trespass on neighboring estates and the concern that the rezoning could set a precedent. The residents who spoke in opposition included two of TR's cousins, John K. Roosevelt and George Emlen Roosevelt. The village board denied the zone change.[218]

Ignoring the local concerns, officials of the Town of Oyster Bay and Nassau County worked to circumvent the village by looking for money to pay for a new access road. The RMA continued discussions with Cove Neck officials, offering to sell all but twenty-five acres around the house to reduce the tax impact as well as closing the existing entrance to the property. Meanwhile, the association worked with county officials and state legislators to pass a state law to allow Sagamore Hill to become a memorial without regard to local zoning. Bills were introduced in Albany on February 6, 1951, to amend the state's Village Law "permitting maintenance of residences of deceased presidents as memorials" by nonprofit organizations. The legislation passed, was signed by Governor Thomas E. Dewey and took effect on March 19.[219]

The RMA consulted with an informal committee of National Park Service officials who visited the property and made suggestions on the access road and other issues. These included restoring the kitchen, pantry and Gun Room for inclusion in the tour, which was done. "The missing rail on the porch, removed to facilitate campaign talks, should not be replaced, because its absence is of unique interest," the committee advised. The association agreed initially but later changed its mind. The park service professionals were unheeded in their urging of the "desirability of preserving existing cultural features as nearly intact as possible, including the historic entrance road, vegetable and flower gardens, stables, and other elements of the grounds." The RMA ceased the farming operations, and the cow shed and chicken coop were removed in 1954 when a 150-car parking lot was constructed on top of the gardens and pasture. (The National Park Service more than half a century later would recommend undoing these changes and re-creating the original appearance of the property, but the plan was not adopted. See chapter 8.) Another change to the property occurred sometime after 1952 when the association acquired about two acres southwest of Sagamore Hill.[220]

The RMA had planned to allow visitors to walk through the rooms of the house. But it accepted a park service committee suggestion for a

self-guided tour without access into the rooms. (The National Park Service would later replace the self-guided tour with group tours led by rangers.)[221]

The RMA planned to name Jessica Kraft, hired by Edith Roosevelt as her secretary in 1945, as a superintendent of the new historic shrine. The park service consultants called Kraft "a very intelligent lady, willing to learn and very loyal to the family." But they urged that she be made curator instead of superintendent because "she has had no experience in operating historic houses," and "a man would be better able to meet all of the problems that will arise."[222]

The park service advisors recommended that the new access road be located south of the house because a roadway to the north would be visible from the piazza. Nonetheless, Nassau County produced a survey for a road that curved around the northwest side of the building. On March 23, 1953, Nassau officials approved the route and designated it as a county road to be maintained by the county. The county attorney was authorized to acquire or condemn any land needed, and in May Nassau took title to eight parcels as well as easements to eight other properties. A construction contract was awarded in July, making the village's four years of opposition moot.[223]

The next hurdle for the RMA was dealing with decades of deferred maintenance. Edith Roosevelt had not put much money into the house in her final years. The exterior woodwork had shed paint, many of the original shingles had disappeared and those that remained were cracked and curled. Inside, a leaky roof and old plumbing had left the wallpaper sagging and stained.[224]

To deal with these problems, the RMA hired Chapman, Evans & Delahanty as architectural advisor and the E.W. Howell Company as contractor in April 1950. It borrowed $25,000 to begin the most essential repairs such as new gutters and replacing rotted wood. In the following two years, a foundation grant, fundraising and gains in the association's investment portfolio paid for new plumbing, heating and wiring, refinishing or replacing floors and new ceilings, exterior walls and an asphalt-shingle roof. The architectural consultant recommended that before the house be opened to the public it needed an adequate water supply for fire protection and a fire alarm, plasterwork, floor and wainscot repairs and improvements to the back stairs to the second and third floor. In May, the RMA agreed to the work.[225]

To accommodate the public, the stairs to the basement were relocated and the staircase to the second floor widened. New stairs from the second to the third floor were built in the western front part of the house. Additional bathrooms were installed in a first-floor closet and two in the basement. The

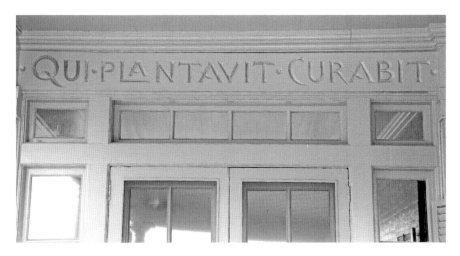

The Roosevelt family motto, which translates to "He who planted will preserve," over the western doorway. *Copyright Audrey C. Tiernan 2016.*

laundry room was converted to an office for the curator. Four rooms on the third floor were altered to display exhibits, and two became storage space, leaving only the Gun Room unchanged. Public restrooms were also installed in the icehouse. In 1956, a souvenir shop, snack bar and restroom facilities were built by the parking lot. The bathrooms in the icehouse were closed but not removed until a major restoration of the house in 2015.[226]

The RMA formed a furnishings committee headed by Bertha Rose to redecorate the house. A Roosevelt family friend, Rose was one of the few experts in historic house interiors in the 1940s, having worked on projects with the Winterthur Museum in Delaware and the Metropolitan Museum of Art in Manhattan. Her group worked from photographs and the recollections of Ethel, Archie and Alice, although it sometimes substituted its own judgment for historical accuracy. The current concept of historic preservation had not been developed yet; the thinking on old houses was to present them as "high style" as possible, rather than re-creating historically accurate spaces. The committee managed to furnish almost all the first floor and much of the second with original furniture and accessories. Artifacts that had been distributed to family, friends and others over the years began to come back for display. For example, when TR's valet James Amos died in 1953, his will included bequests to the Theodore Roosevelt Association, a later incarnation of the RMA, of items the Colonel had given him, including an elephant's foot, a hoof of a rhinoceros with a silver inkwell set in it and a Winchester rifle.[227]

Sagamore Hill opened on June 14, 1953, with President Dwight D. Eisenhower, former president Herbert Hoover and Governor Thomas Dewey on hand to dedicate the house as a shrine. The *New York Times* reported on the front page that about ten thousand attended. There to greet the dignitaries were Alice, Archie and Ethel, Ted and Kermit's wives and other relatives, including a half dozen great-grandchildren. Ethel showed the president through the house. In his speech, Eisenhower noted there was a tendency to think of TR as the charging Rough Rider, but this was a misconception.

> *We like to think in his relationships with the Congress that he galloped down Pennsylvania Avenue on a spirited charger with his sabre drawn, rushed into the Senate or the House, demanded what he wanted and rode out with everybody cowed. . . . But the fact is he was a wise leader. He wasn't a swashbuckler and he was not a bull in a china shop. . . . He was a great leader and a great student and a great writer. . . . He was a man who understood his fellow human beings.*[228]

The initial visitors had access to the first floor, the four exhibit rooms on the third floor and a small souvenir shop that occupied Alice's bedroom on the second floor.[229]

The RMA, which changed its name to the Theodore Roosevelt Association (TRA) in 1953, reported healthy attendance at the house museum. Kraft told a local weekly newspaper in October that almost 50,000 individual visitors had crossed the threshold and paid the half-dollar admission, and at least that many children had come with school or Scout groups. Kraft said completion of the new access road would boost the numbers. Even with the high visitation, the TRA was incurring a deficit managing the property and began looking for savings, particularly in personnel costs. On August 16, 1956, Kraft reported, the 200,000[th] paid visitor was admitted. It was Kate Strong of Setauket, Long Island, "a great admirer of Mr. Roosevelt," who was presented with a copy of the book *Roosevelt the Industrialist*. On a less upbeat note, the curator noted that a small revolver and hunting knife were missing from the Gun Room and a spoon from the kitchen. Also, that year, Alice's bedroom and the boys' northeast bedroom were refurbished and opened to the public while the original back porch was enclosed to provide a staff kitchen. Alice donated furniture and a rug for her former bedroom while Ethel provided a dresser, pincushion, figurine and linen.[230]

President Dwight D. Eisenhower and former president Herbert Hoover at the dedication of Sagamore Hill as a national shrine on June 14, 1953. *Courtesy of the National Park Service, Sagamore Hill National Historic Site.*

The cost of operating Sagamore Hill continued to trouble the TRA. The association, which had merged with the Women's Roosevelt Memorial Association in 1953, had been spending a lot of money in Cove Neck and elsewhere. The group's budget for 1961 showed that the purchase and restoration of the Cove Neck site had been budgeted at $400,000. Purchasing the Manhattan property and rebuilding Theodore Roosevelt Birthplace

was budgeted at $540,000, the cost of Theodore Roosevelt Memorial Park in Oyster Bay was $700,000, the gift of Theodore Roosevelt Island in Washington to the nation had a preliminary expense of $475,000 and the donation of Roosevelt's letters and other items to the Harvard College library was valued at $300,000.[231]

To prevent depletion of its assets, the organization began to pursue a transfer of Sagamore Hill and the birthplace to the National Park Service. Secretary of the Interior Stuart L. Udall inspected the house on May 25, 1963, and said, "It would be a very fine addition to the National Park System," the *New York Times* reported. Udall added that he did not know of any other national historic site "with the particular flavor and feeling of this place. You almost feel as if Teddy Roosevelt was going to stride in the door." The article noted that Sagamore Hill had been visited by more than half a million adults and hundreds of thousands of schoolchildren in the previous eight years.[232]

While negotiating with federal officials and members of Congress, on August 1, 1961, the TRA sold the northern eleven acres of the fifteen acres known as Smith's Field jutting north from the western end of the property. The portion sold included the Nest, Edith Roosevelt's getaway spot. The sale left the association with seventy-two acres. Shortly before donating Sagamore Hill to the National Park Service, in 1963 the TRA bought two lots totaling four acres around Old Orchard from the estate of Ted Jr.'s widow Eleanor, who had died in 1960. This was the same land that Edith Roosevelt had given to her son. The purchase brought the size of the property offered to the federal government to approximately seventy-eight acres.[233]

The TRA's intent was to donate the Cove Neck and Manhattan properties along with a $500,000 endowment. Legislation to make that possible was introduced in Congress. Five congressmen on the committees considering the bill came to the house in February 1962 and were given a tour by Ethel Roosevelt Derby. In the drawing room, one newspaper account related, TR's younger daughter said, "My mother didn't like big-game hunting and animals and that sort of thing and she kept them out of this room. She did like Admiral Peary, though, and what he'd done so she didn't object to this polar bear. He caught it." On April 2, 1962, the House of Representatives unanimously passed the bill to establish Sagamore Hill and the Theodore Roosevelt Birthplace as national historic sites. Senate approval followed on July 18, and the legislation was sent to President John F. Kennedy. On July 22, TRA board president Oscar Straus mailed Ethel a one-sentence message: "The President signed the Bill last night!" He wrote to Archie and

From left to right: Alice Roosevelt Longworth; her sister, Ethel Roosevelt Derby; and their sister-in-law Eleanor Alexander Butler Roosevelt at the dedication of Sagamore Hill as a national shrine on June 14, 1953. *Courtesy of the National Park Service, Sagamore Hill National Historic Site.*

Alice the same day to say, "This development . . . makes secure the continued existence of these two Memorials to your Father, in perpetuity."[234]

The park service offered jobs to the TRA's six employees at Sagamore with Kraft continuing as curator.

Udall, after trying unsuccessfully to get JFK to preside at the ceremonies, accepted the deeds for Sagamore and the birthplace at both homes on July 8, 1963. They became the National Park Service's seventeenth and eighteenth national historic sites. The interior secretary gave a four-and-a-half-page speech, in which he noted:

> *Roosevelt's love affair with nature was mutual from the start, and already the park system has a monument to that romance—the wild little island in the District of Columbia. . . . But our Nation needs another kind of reminder of its first conservationist president. . . . In a nation which is teetering on the brink of overcrowding and underproviding for out-of-door recreation opportunities, it is well to have a conventional monument to the*

president who first turned the eyes of the nation from the balance sheets of commerce to the balance sheets of nature. . . . The charm and flavor not only of the home itself, but of the family which inhabited it, have been faithfully and tastefully preserved. This site is Theodore Roosevelt as no other tangible thing in this world today is.[235]

The *Federal Register* noted that on July 15, 1963, Udall established Theodore Roosevelt Birthplace and Sagamore Hill National Historic Sites.

8

A National Historic Site

As soon as the federal government acquired Sagamore Hill, the National Park Service began making changes—a process that is still ongoing. Every project has addressed either or both of two goals: to preserve the structures and grounds for the future and bring them closer to their appearance at the start of the twentieth century to improve the interpretation for visitors.

After the Theodore Roosevelt Association's donation of the Cove Neck property, the park service named Franklin Mullaly as the first superintendent. By 2016, ten more would follow. Mullaly served only six months. In early 1964, the site became part of a New York City Group without its own supervisor until Roy Beasley became superintendent of a once-again independent Sagamore Hill in 1977.[236]

Not until 1965 did the park service begin work on the main house, which the agency began to call the Theodore Roosevelt Home to distinguish it from the overall site. The initial project restored porches, window frames and interior masonry. Bigger changes came the following year. The four exhibition rooms and other areas on the third floor were restored to replicate their original appearance. Those changes were based largely on information from Archie and Ethel. Most of the furnishings were purchased for four servants' rooms, a schoolroom, Ted's bedroom, a trunk room and a linens room because the original artifacts had been disposed of in 1953 when there were no plans to show the third floor in its historic appearance. There were two other notable events in 1966. Ted's Old Orchard home was converted

The front hall and stairs in 1964. *Courtesy of the National Park Service, Sagamore Hill National Historic Site.*

into the Old Orchard Museum, where items that would not have been in the house during the presidential years could be displayed and the family's history told. And Sagamore Hill was listed in the National Register of Historic Places on October 15.[237]

The agency prepared a master plan for the new park in 1963 but never formally approved the document. It suggested restoration efforts such as removing a porch added to the New Barn in the 1940s and returning the structure to its original appearance. That suggestion was never carried out. The barn continues to be used as a residence for employees. A subsequent general management plan that was approved calls for restoring the barn and using it as a new visitor center. Gray Cottage had become vacant by 1950 and was renovated by the TRA in the 1950s as leased housing. It was rehabilitated again by the NPS in 1964 and since then has been used as a staff residence.[238]

In 1968, the park service reversed changes to the western side of the piazza, removing the rebuilt steps and railing installed by the TRA. The front hall was restored between 1978 and 1983.

Significant alterations in the appearance of the house came in the 1980s. Historically appropriate wood shingles replaced the modern roof in 1984.

A paint analysis the following year revealed that the original color scheme, thought to have been ocher and green, was gray. As a result, the house was repainted that color, shocking and dismaying many people who had only known the more colorful variation.

Also, in 1985, a five-acre parcel located north of the new county access road and west of Sagamore Hill—land never owned by Theodore Roosevelt—was purchased by the Trust for Public Land. It was transferred to the Department of Interior, bringing the national historic site to its present eighty-three acres.[239]

The Roosevelt home, like most Queen Anne structures, has always been dark inside. Illuminating the interior for visitors was a problem since the house was opened to the public in 1953. The light fixtures in the first four decades of museum operation were so dim that visitors had a hard time making out what was in each room from the doorway. Guides sometimes used flashlights on cloudy days. Finally, in 1988, the NPS removed thirty-year-old fixtures that were both anemic and so out of the character with the house that Jessica Kraft had derided them as "disco lights." They were replaced by gas fixtures found in the attic and wired for electricity.[240]

The park service knew that some of the redecorating done before the house opened in 1953 was historically inaccurate. Bertha Rose's Roosevelt Memorial Association furnishings committee sometimes substituted its own judgment for family members' recollections or photographic evidence. For example, the committee decided to display all of the family's heavy Pabst chamber furniture in the master bedroom even though there was ample documentation that the wardrobe had been in the nursery. These decisions were overturned after a historic furnishings report in 1990 precipitated the biggest changes in the house since it opened for visitors. The study was prepared by David Wallace, a curator with the park service's Historic Furnishings Division in Harpers Ferry, West Virginia, who said, "I found documentation which indicated that some of the decisions made in the Fifties needed to be changed because of additional information like newly discovered photographs, letters from Mrs. Roosevelt to her family and so on." In addition, his report noted that the association decided to display popular items such as safari trophies, even though they were not in the house during the presidential years, 1901 to 1909, the period that was supposed to be reflected in the decoration.[241]

To rectify these inaccuracies, about five hundred objects were relocated while the house was closed for six months in the beginning of 1993 to also allow a makeover of five second-floor rooms and reconstruction of

deteriorating plaster and woodwork in three hallways. The changes included some that were obvious, such as banishing the large wardrobe from the master bedroom down the hall to its original location in the nursery. But few were likely to notice that the rhinoceros-foot inkwell in the North Room had traded places with the Lincoln-bust inkwell in the library. Because some of the most beloved pieces dated from after TR's time as president, the park service decided to broaden the time period depicted in the house to include the post-presidential years: 1910 to 1919.

The furnishings report pointed out that the first floor was decorated almost entirely with original pieces, with fewer Roosevelt artifacts on the upper floors. Based on the report, NPS purchased 225 objects from the proper time period and wove them into the furnishing scheme for the upper floors. Some replicas made by Sagamore Hill craftsmen, including a canvas infant bathtub for the nursery, were also added. The second floor is now 75 percent original and the third floor 35 percent, higher than the percentages in the report, thanks to recent acquisitions, the curators note.

After the furnishing study changes, visitors were allowed to see areas previously off-limits, such as the wainscoted "splash closet" next to the boys' room with its shower installed about 1907. At the same time, NPS abandoned the self-guiding tour system with plaques by the doors and rangers available to answer questions. It shifted to guided tours to improve visitors' understanding and better protect the house and its artifacts. With guests no longer roaming without supervision, the agency removed the wooden gates blocking access to the rooms on the second and third floors and replaced them with less obtrusive velvet ropes.[242]

Another issue for park personnel in interpreting Sagamore Hill was that it was hard to tell that the property had been a working farm when Theodore Roosevelt lived there. While there were displays of farm implements in sheds, a windmill and a few trees remaining from the orchard, the parking lot covered most of the gardens and some of the cultivated fields. Other once-cultivated fields had been left to natural grasses. To make it easier to understand how the property was used initially, the park service in 2002 began to restore a portion of the 3.2-acre garden as part of a larger ongoing plan to return the house and grounds more closely to their original appearance. The restoration on the westernmost acre of the former gardens included re-creating what had been its focal point—a rose arbor. To determine what should be incorporated in the restored space, the park service hired Richard Thomas of Soulscape Garden and Floral Design in Manhattan. He spent three months researching photographs and records,

The Theodore Roosevelt Home surrounded by scaffolding during a three-year $10 million restoration completed in 2015. *Photograph by the author.*

including a drawing of the garden made by Archie. "We know from the records that Roosevelt loved gold roses," Thomas said. Roses, along with moonflowers and sweet autumn clematis, were planted on the twelve-foot-high arbor after it was built in the spring of 2003. Thomas learned that the family planted a long list of annual and perennial flowers, including black-eyed Susans, asters and lupine in the cutting garden, and these, along with berry bushes, were included in the restoration.[243]

All national park sites were supposed to operate under general management plans that specify how they should be run and their future needs. Since the draft plan for Sagamore Hill created in the 1960s was never adopted, in 2004 the NPS began work on a new document to remedy that omission. The planners looked at many critical issues: Should a new visitor center be created? Should the Old Orchard Museum be expanded to incorporate storage for artifacts kept in the moldy basement of the old house? And most important, should the site more closely resemble its appearance during TR's lifetime? That last question raised controversial issues, such as should the parking lot be relocated away from the central core of the property and should trees that had grown up to block the view of Oyster Bay Harbor that Roosevelt enjoyed be cut down?[244]

A year later, park officials answered those questions in a draft plan containing several options. The Sagamore staff supported the most ambitious and radical one. That called for removing the ninety-space parking lot in the center of the property and building a new lot and visitor center on the northwestern corner of the property down the hill—and out of sight—from the main house. Trams or shuttle buses would take visitors up to the house. The goal of this alternative was to re-create as closely as possible the look of the Cove Neck site when Roosevelt was president, following the example of many other presidential homes such as Mount Vernon, Monticello and the Hermitage, which keep cars and other signs of the present day far away from the historic buildings and core of the property. Another alternative would have eliminated a third of the parking lot to allow the re-creation of more of the gardens. All the alternatives called for upgrading the mechanical systems and installing a fire-suppression system in the house.

Superintendent Gay Vietzke said many visitors were disappointed by the existing site layout. "There are a lot of folks who wish we had some place where you would go and be oriented to the entire place and make it easier to plan your visit, rather than just coming up the hill and into a big parking lot and then having the experience split between the visitor center and the house with Old Orchard in the opposite direction," she said. But Norman Parsons, president of the Theodore Roosevelt Association, essentially killed the proposal single-handedly with his opposition. "The reason that people go to Sagamore Hill is the house," he said, and the existing parking was closer to it than the new lot would be. He objected to a new building on the property and anticipated neighbors would fight any new construction or increased activity nearer their homes. The current president of the TRA board, Tweed Roosevelt of Boston, a great-grandson of the Colonel, believes the organization made a mistake in opposing the staff's preferred recommendation in 2005 and would like to see the park service revisit the idea of relocating the parking lot to the edge of the property.[245]

The less ambitious management plan that was adopted did not recommend expansion of Old Orchard. It did recommend transforming the New Barn into a visitor center to replace the existing small information center–gift shop.

With removal of the parking lot rejected, the park service began undertaking small projects to bring the house and grounds closer to their historic appearance. For almost a century, the surface under the porte-cochère had been asphalt. As part of a $775,000 initiative to make the property more historically accurate, the bricks that TR had decided should be laid out in a

Framing for re-creation of the air and light shaft in the center of the house that was removed in the 1950s before it opened as a museum. *Photograph by the author.*

herringbone pattern under the shelter for visitors arriving by carriage were unearthed in 2008. The staff was not even sure the bricks remained under the asphalt put down about 1910 when a macadam driveway was installed. But earlier repairs to the porte-cochère indicated the bricks might be there, and removing the asphalt carefully by hand revealed them. Some bricks that had crumbled because of heavy traffic were replaced.[246]

A project begun in 2010–11 stemmed from the management plan's goal of restoring 6.2 acres of former farm fields, orchard and lawns. The park service replanted a portion of the original fruit orchard east of the parking lot. Forty-six Baldwin, Roxbury Russetts and Winesap apple trees and Seckel pear trees were planted among twenty surviving fruit trees to reestablish the historic grid pattern of the orchard. In other work to restore more of the property, about six hundred feet of split-rail fence was installed along with a replica of the arbor that had been located at the pet cemetery. And two acres of new-growth trees and shrubs on part of the West Lawn and two farm fields southeast of the house and south of the parking lot were removed. NPS had begun cutting down trees that had grown up since the early 1900s on the West Lawn adjacent to the house a decade earlier and restored four historic farm buildings. The replica windmill constructed in the early 1970s was rehabilitated at a cost of almost $200,000.[247]

A small section of the cutting garden was re-created in 2012. About five hundred square feet of some of the same flowers that were lost to the paving of the access road and parking lot as well as lack of maintenance were planted around a new welcome sign installed in a circle of grass at the entrance to the parking area. The miniature garden featured a mix of annuals, perennials and shrubs, including carnations, petunias, marigolds, zinnias, snapdragons, larkspur, chrysanthemums, clematis and moonflower, with annuals for color.[248]

While all of this work was taking place on the grounds, the staff was gearing up for the biggest project at the house since its construction. It would turn out to be a $10 million rehabilitation from foundation to roof that required closing the building for three years.

Theodore Roosevelt might have had limitless energy, but by the beginning of the twenty-first century, his residence was tired. The rejuvenation project included rewiring and relighting the entire house; upgrading the heating and ventilation, security, fire detection and suppression systems; putting on a new roof; and rehabilitating the entire exterior, including all the windows and adding new storm windows. The biggest change for visitors would be improved indirect lighting in the iconic trophy-filled North Room; in the

past, the dim illumination made it impossible to see the far wall or much of the detail from the barrier at the entrance. Attentive repeat visitors might also notice that the addition built on the back porch in the 1950s would be removed. And the central light and air shaft from the second floor to the roof removed at the same time would be re-created. The project would also make the first floor permanently handicapped accessible, replacing temporary ramps from the 1980s.

The project required extensive planning and preparation. Sagamore Hill museum specialist Susan Sarna supervised the process of removing eight thousand books and six thousand other artifacts ranging from

A conservator from the Northeast Document Conservation Center touching up the wallpaper in the North Room during the restoration. *Photograph by the author.*

an elephant foot wastepaper basket to a grizzly bear rug to make way for the construction crews. The first step was to update the 1964 house inventory, including built-in items such as mantels and even wallpaper. A spreadsheet was created for each room listing every object with its history, photograph, details on where it had been displayed and a description of its materials. Next was devising a plan for removing what could be removed and protecting the rest in place. "We have a master plan for every single object in the house—where it's going, when and how it's going to be packed, and who is going to pack it and where it's going to be stored," Sarna said at the start of the project. There was a $100,000 budget just for packing and moving and $150,000 for off-site storage of artifacts that would not fit into the Old Orchard Museum. Three NPS conservators who specialize in furniture, taxidermy and paintings made suggestions on packing and transportation, and they also helped determine

which items needed immediate repairs to withstand the strain of being moved. About a dozen damaged frames were repaired. After undergoing specialized training, Sarna instructed other staff members and experienced volunteers on packing items.[249]

Those objects that could not be removed safely became the responsibility of Jeff Finch, an NPS regional historic building specialist who has developed a niche expertise of installing protective walls and flooring in historic buildings undergoing restoration. Over more than ten weeks he designed and installed a system of false walls and other coverings to protect all the built-in features. Besides covering walls, staircases and bookcases, Finch protected an armoire in the third-floor linen closet—the only piece of furniture to remain in the house because it was large and did not come apart. Finch also wrapped mounted animal heads considered too fragile to disturb. "He never uses any nails or puts holes in anything," Sarna marveled. Finch's ingredients are plywood, furring strips, sheets of thin plastic foam, cardboard tubes, plastic sheeting and special plastic flooring. "It's all done with friction and gravity," he explained, with an occasional assist from blue painter's tape.[250]

After Finch had installed his cushioning, the contractors moved in, including those trying to wrestle with the perennial problem of heating and cooling the house. Climate control had always been an issue for the park service, just as it was for TRA and the Roosevelts. When the massive rehabilitation was being planned, the possibility of adding air-conditioning to resolve chronic problems with high humidity and heat was discussed and then rejected. Sarna, other NPS staff, the consultants and contractors came to understand that the house had been designed by Lamb and Rich with an effective ventilation system—the light and air shaft running from the second floor to the roof that had been removed during the 1950s renovations. "We realized that the architects knew what they were doing and the air was meant to circulate through the house through this air shaft and taking it out and putting in a fan wasn't working," said Sarna, now Sagamore Hill's museum curator. It was decided to re-create the shaft, solving the ventilation problem while making the house more historically accurate. The air shaft was augmented by two new ventilation systems to improve circulation and remove humidity without air conditioning. Another visible change was the return of the rear service porch also removed in the 1950s. The addition that enclosed the porch with its brick arch to create a staff break room is now gone.[251]

The rehabilitation project, which was partially funded by the nonprofit Friends of Sagamore Hill, yielded some interesting artifacts. Carpenter

Sagamore Hill National Historic Site museum curator Susan Sarna unwrapping books for reinstallation prior to reopening the house in July 2015. *Copyright 2015 Robert A. DiGiacomo.*

Richard Vischof was working in a second-floor bedroom when he found two business cards inside a window sash. On a whim, he called the number printed on them and connected with carpenter John Bruckner, who helped overhaul the house nearly four decades earlier. Bruckner, eighty-four, returned to visit, and his business cards became part of an exhibit about the restoration at the Old Orchard Museum along with antique tools, horseshoes and a calendar from 1918 all found inside the walls.[252]

When the contractors were finished, NPS and private conservation experts moved in. Wallpaper in the North Room dating to 1905 that had been damaged by leaks and removed for restoration by the nonprofit Northeast Document Conservation Center in Massachusetts was rehung using a protective methyl-cellulose adhesive solution. Staffers at the center spent weeks removing surface dirt and adding special long-fiber Japanese paper to its back side to reinforce it. Other wallpaper was touched up on site with the same solution to stabilize it. The conservators spent almost a week using a removable paint to re-create details worn away by early visitors. Other workers installed ultraviolet protective film over the glass of repaired windows to protect the interior of the house from sun damage and make it easier for visitors to see inside the rooms.[253]

More than two thousand visitors lined up on July 12, 2015, to see the Theodore Roosevelt Home when it reopened. Among those in attendance were five members of the Roosevelt family. "They did a tremendous job," TR's great-grandson Tweed Roosevelt told the crowd. "It's pristine but not so much so that it doesn't look lived in." Theodore Roosevelt IV, another of TR's great-grandsons, added, "It is clearly in better condition than it was when the Old Lion was here."

As for the future, the park service plans to continue the effort outlined in the general management plan to bring Sagamore Hill closer to its historical appearance. That would include removing the visitor center–gift shop to restore the historic chicken yard that was on that spot and create a new visitor center in the New Barn if funding becomes available. But for now the Theodore Roosevelt Home is in bully shape.

Despite spending $10 million on planning and execution of the exhaustive rehabilitation, Sarna said, "We don't want the visitor to know we did anything, even though we have enhanced the visitor experience and preserved the house for the next one hundred years."

Appendix

The House and Grounds Today

S agamore Hill is a time capsule of the lives of Theodore and Edith Roosevelt and their children. Their personalities and interests radiate from every room of the comfortable Queen Anne home.

But Sagamore Hill National Historic Site is more than just the Theodore Roosevelt Home. Its eighty-three acres include thirty-four acres of natural areas, including woods, marshes and shoreline. There is also the Old Orchard Museum with family history and artifacts. And there are outbuildings, some with displays. Many visitors fail to spot and follow the delightful trail leading from Old Orchard down through the woods to the beach on Cold Spring Harbor where the Roosevelts swam and rowed.

Here is a guide to the house and other key structures on the property. You can refer to the color insert in the center of this book to see the rooms and structures discussed here.

THE PIAZZA: The porch that wraps around the west side of the house was the family's outdoor place to relax. There was space underneath it for the younger children to play or hide. It was also where TR gave speeches and posed for photographs with visitors. It was altered when the North Room was constructed in 1905, and then or shortly thereafter, the steps on the west side, along with sections of the railing, were removed to create a speaking platform. In 1960, the Theodore Roosevelt Association restored the steps and railing for the safety of visitors. In 1968, the National Park Service returned the porch to the 1905 design by again removing the stairs and railing.[254]

FIRST FLOOR

THE FRONT HALL: This space functioned as the Roosevelts' formal living room or sitting room, with chairs and a small couch in front of the fireplace, until the North Room was constructed in 1905. In the summer, family members left tennis rackets in the fireplace and tennis balls in blue jugs on the mantel to keep them handy. The large statue of a rhinoceros given to TR by his sister Corinne was not a favorite of Edith's, who used to hang her gardening hat over the horn to hide the sculpture.[255]

THE LIBRARY: In the early days, it was not only the repository for hundreds of books but an informal family room. This was possible because Roosevelt did his serious writing in the Gun Room on the third floor or, between 1898 and 1901, in the Gate Room on the second floor. But from the time TR became governor, he used this room as his office. Generally, it was no longer the family sitting room, except on cold nights, because it was easier to heat than the North Room, added in 1905. After TR became president in 1901, the library was where he met daily with White House staffers as well as diplomats and cabinet members. One of two telephones in the house was installed here. After Roosevelt left the White House, the library resumed its earlier role as a family room.[256]

THE DRAWING ROOM: Originally called the parlor until it was modernized, it was the one space in the house that Edith Roosevelt could call her own and decorate to her tastes. But there were masculine touches: lion and bearskin rugs that were presents from her husband and a polar bear rug that was a gift from Rear Admiral Robert E. Peary after his 1909 expedition seeking to reach the North Pole. Mrs. Roosevelt entertained her guests in the room. She kept a desk there to manage the family's finances and handle her correspondence. Her personal library was also housed in the room. She continued to use the space for the same purposes after her husband's death.[257]

THE DINING ROOM: The table, chairs and sideboards were purchased by Theodore and Edith during their honeymoon in Italy in 1887. The bench was from TR's parents' home on West Fifty-Seventh Street in Manhattan. The embroidered screen in front of the pantry door was a gift to Edith from the empress of Japan. Mrs. Roosevelt sat at the eastern end of the table so she could communicate with the serving staff behind the screen. Conversations during meals were usually lively and covered a broad range

of topics. Even when guests were not present, meals at Sagamore were formal—the Roosevelts always dressed for dinner. The boys were expected to stand when their parents or any women, including their sisters, entered. If the children were not on time, they had to wait until the family had finished dining and then eat in the kitchen. When guests did join the family, which was a frequent occurrence, the children usually ate with them and were required to display proper manners and participate in the discussions.[258]

THE KITCHEN: Edith Roosevelt met with the cook here every morning to plan menus. During the Summer White House years, breakfasts and dinners usually included only family and close friends. Lunch was another matter, with visitors almost constantly present. Some days, the kitchen staff would prepare as many as four sittings to accommodate the family, White House and Sagamore Hill staff and guests. Much of the food was produced on the property.[259]

THE PANTRY: Here the waitress—or the butler during the presidential years—received dishes from the cook and delivered them to the dining room. Silver, jewelry and other valuables were kept in a safe across from the china cabinet. When Sagamore became the Summer White House in 1902, a wall telephone was installed in this room. If the butler was not on duty, the president might answer himself. When he was no longer chief executive, Roosevelt wanted to eliminate the telephone, which he viewed as a nuisance. But his teenage children talked him out of it.[260]

THE NORTH ROOM: The Roosevelts constructed this addition in 1905 to receive important guests and serve as a family living area after Edith tired of using her drawing room as a waiting area for TR's visitors. It was decorated with hunting trophies, TR's Spanish-American War Rough Rider hat and saber as well as other artifacts. The large elephant tusks at the entryway were presented to TR by the emperor of Abyssinia. Among the family events held here was Ethel's 1913 wedding to Dr. Richard Derby. After 1909, the family Christmas tree was set up in this room. When TR died, his coffin rested here, and Edith Roosevelt read prayers next to it before his funeral in Oyster Bay on January 8, 1919. After that, she had a temporary partition built across the landing to close off the North Room. It was only opened for special occasions, such as when King Albert of Belgian came to pay his respects later that year.[261]

SECOND FLOOR

MOTHER'S ROOM: Theodore and Edith Roosevelt shared this bedroom, but the children always referred to it as Mother's Room because during the day, it served as her dressing room and private sitting room. Edith frequently spent summer afternoons on its little porch. In the winter, the northwest exposure made it one of the coldest rooms. The bird's-eye maple furniture came from TR's parents' West Fifty-Seventh Street home in Manhattan. After TR died, Edith moved to the sunnier South Bedroom.[262]

FATHER'S DRESSING ROOM: TR used this space to prepare for the day and bed from 1885 to 1900 and again from 1906 to 1919. It shares a connecting closet with Mother's Room. After TR died in 1919, the room became Edith Roosevelt's dressing room.[263]

THE GATE ROOM: This southwest room with a connecting door to Mother's Room was the original nursery. It takes its name from a wooden gate across the doorway that prevented young children from falling down the stairs. From 1900 to 1906, it was TR's dressing room, and in 1898 and 1901, it doubled as his private study because the Gun Room on the third floor had been converted to a schoolroom. It became Ethel's bedroom from 1906 until her marriage in 1913. Then it was a guest room. During World War I, Ethel and her two children moved back to her parents' home while her husband was serving at a hospital in France. Their son, Richard, and daughter, Edith, shared the Gate Room while Ethel stayed in the South Bedroom. Ethel had to scold her doting father for waking the children from their naps. TR spent his last days on the sofa in the Gate Room, where he was also sleeping because it was warmer than the bedroom he shared with Edith. It was here that TR died in his sleep early in the morning of January 6, 1919. It continued to be a spare bedroom until Edith Roosevelt's death in 1948.[264]

THE NURSERY: This was the "work room" where infant clothes and supplies were stored, babies were bathed and dressed and the young children took naps. The drawing of Santa Claus in the White House was a gift from famed illustrator Thomas Nast.[265]

THE SOUTH BEDROOM: This room, along with the nursery and Gate Room, was used for the care of young children through the 1890s. The South Bedroom was where the nurse slept with the youngest children. It mostly

served as a guest room during the presidential years. After TR's death in 1919, Edith used it as her bedroom until she died there in 1948 at age eighty-seven.[266]

Alice's Room: As the eldest of the six Roosevelt children, Alice was the first to get her own room at the age of eight in 1892. It was furnished with a bedroom set that belonged to her mother, Alice Hathaway Lee Roosevelt, who died soon after giving birth to her. After Alice married Congressman Nicholas Longworth at the White House in 1906, her brother Kermit claimed her room. He demanded that his mother replace the furniture, so Alice kept it. She donated it back to Sagamore Hill when her room was refurbished to its original appearance in 1956.[267]

The Boys' Room: The four Roosevelt boys often shared bedrooms. Over the years, all lived in this room, either sharing or alone. By about 1903, all of the children had their own rooms. The contents demonstrate the brothers' interest in sports, games and reading.[268]

Double Guest Room: Relatives and close family friends were invited to stay overnight. Most enjoyed the experience. One exception was TR's close friend and statesman Henry Cabot Lodge, who grumbled: "The Roosevelts stayed up too late, talked too loud, and got up too early in the morning."[269]

Single Guest Bedroom: This small room was most likely used by visiting relatives such as TR's favorite niece, Eleanor, the future First Lady. The Roosevelt children tried to appropriate this room as a bedroom, but their mother insisted that it remain available for guests.[270]

Third Floor

Gun Room: The architects designed this light and airy space with a view of Oyster Bay Harbor as a billiards room and den. But the Roosevelts used it for various other purposes, most frequently as TR's study. Ted gave the room its name because of the firearms stored there. The children played there and in a closet under the eaves, and TR would read or tell bedtime stories in front of the fireplace. In 1898 and again in 1901, it was used as a schoolroom by a teacher tutoring the boys. It was here that Roosevelt wrote his biography

of Gouverneur Morris in 1887, and he was still using it in 1898 to write *The Rough Riders*. The staff hired by TR to help him with his books worked with him in the Gun Room. TR preferred to dictate to a stenographer, and then a typist would sit at the desk and transcribe the notes.[271]

TED'S ROOM: The eldest son was first given his own bedroom in 1894, at age seven, on the second floor next to Alice's. This third-floor space was used as a bedroom by a succession of nurses and governesses in the 1890s. Then in 1902, when Quentin started school and no longer needed a governess, fourteen-year-old Ted convinced his mother to let him move upstairs. The contents reflect Ted's interests: sports, hunting, photography and books. After Ted married in 1910 and moved out, Archie moved in.[272]

COOKS' ROOM: This was where the Roosevelts' cooks lived. Over the years, the household staff ranged from four to nine people. Besides the cook, there was a valet who doubled as a butler, a lady's maid, a nurse, a governess and maids. Two of the cooks, Annie O'Rourke and Brigid Turbidy, each stayed with the family for more than twenty-five years.[273]

MAIDS' ROOM: Unmarried female servants lived on the third floor. Some of them worked for the Roosevelts for decades and almost became like members of the family. Mary Ledwich, known as "Mame," had been Edith's nurse when she was a baby and came to Sagamore in 1887 when Ted was born and stayed until Quentin started school.[274]

ON THE GROUNDS

ICEHOUSE: The octagonal structure built in 1885 on the east side of the house was used to store ice cut from nearby ponds. After TR became president, ice was delivered and stored there. The building also contained storage tanks of about two hundred gallons each for the estate's reserve water supply. When the property was opened to the public in 1953, bathrooms were installed in the structure. They were replaced by restrooms near the parking lot in 1956, but the plumbing was not removed until a 2015 renovation.[275]

THE NEW BARN: This structure was built northeast of the house in 1907 to replace an earlier barn that collapsed. It was altered to become a residence

and garage to accommodate a caretaker and his family along with the estate's automobiles around 1947. Since the property opened to the public in 1953, the barn has served as a staff residence. The National Park Service's Sagamore Hill general management plan calls for converting the building into a visitor center.[276]

GRAY COTTAGE: The Roosevelts constructed this dwelling eight hundred feet southeast of the house in 1910 for the families of two servants. It is now housing for National Park Service employees.[277]

OLD ORCHARD: Theodore and Edith's eldest son, Ted, built the house on four acres his mother gave him in 1938. After Ted died in World War II, his widow, Eleanor, remained in the house until her death in 1960. Three years later, the Theodore Roosevelt Association purchased the property so it could be donated along with Sagamore Hill to the federal government. In 1966, the National Park Service converted the building into the Old Orchard Museum, where items that would not have been in the house during the presidential years are displayed and the family's history is told. It also contains staff offices and archival storage.[278]

Notes

INTRODUCTION

1. Wallace, *Historic Furnishings*, 16; Bellavia and Curry, *Cultural Landscape*, 26.
2. Bishop, *Theodore Roosevelt's Letters*, 165.

CHAPTER 1

3. Lee, *Gray Cottage*, 18.
4. McCullough, *Mornings on Horseback*, 111.
5. Hammond and Roosevelt interview.
6. Department of the Interior, *Historic Resource Study*, 15; Bellavia and Curry, *Cultural Landscape*, 14; Hammond and Roosevelt interview.
7. Department of the Interior, *Historic Resource Study*, 15.
8. McCullough, *Mornings on Horseback*, 141–43.
9. Roosevelt, *Autobiography*, 7.
10. Department of the Interior, *Historic Resource Study*, 15.
11. Hammond and Roosevelt interview; Department of the Interior, *Historic Resource Study*, 15–17, 128.

CHAPTER 2

12. Hagedorn, *Roosevelt Family*, 6; Lee, *Gray Cottage*, 4.
13. McCullough, *Mornings on Horseback*, 250; Hammond and Roosevelt interview.
14. Hammond and Roosevelt interview; Bellavia and Curry, *Cultural Landscape*, Foreword.
15. Lee, *New Barn*, 19; Department of the Interior, *Historic Resource Study*, 18; Bellavia and Curry, *Cultural Landscape*, 26; Carden and Crissen, *Historic Structure Report*, 19.
16. Theodore Roosevelt Association records, Abstract of Deeds.
17. Bellavia and Curry, *Cultural Landscape*, 24, 26.
18. Roosevelt, "Outdoors and Indoors."
19. Department of the Interior, *Historic Resource Study*, 15.
20. Hagedorn, *Roosevelt Family*, 6; Carden and Crissen, *Historic Structure Report*, 15.
21. Contract in archives at Sagamore Hill National Historic Site; *Cultural Landscape*, 34–35.
22. Roosevelt letter to editor of *Country Life in America* on October 3, 1915, Houghton Library, Harvard University.
23. Lee, *Gray Cottage*, 9; DeWan, "White House."
24. Contract in archives at Sagamore Hill National Historic Site.
25. *Historic Resource Study*, 19, 21.
26. Information from Sagamore Hill museum curator Susan Sarna.
27. *Historic Structure Report*, 15; National Register of Historic Places nomination form.
28. *Historic Structure Report*, 16; Sarna.
29. *Historic Structure Report*, 6; *Historic Resource Study*, 21.
30. Roosevelt, *Letters*, 73.
31. Ibid., 81.
32. DeWan, "White House."
33. Abstract of Deeds; *Cultural Landscape*, 20; *Historic Resource Study*, 128.
34. *Historic Resource Study*, 15–17, 128; *Cultural Landscape*, 21.
35. *Cultural Landscape*, 37.
36. Hagedorn, *Roosevelt Family*, 12–13; Wallace, *Historic Furnishings*, 7.

CHAPTER 3

37. Hagedorn, *Roosevelt Family*, 9.
38. Ibid., 15.
39. Roosevelt, *Letters*, 117–18.
40. Morris, *Edith Kermit Roosevelt*, 106; Hagedorn, *Roosevelt Family*, 3, 15–16; Wallace, *Historic Furnishings*, 7.
41. DeWan, "White House"; Morris, *Edith Kermit Roosevelt*, 109–111.
42. Hagedorn, *Roosevelt Family*, 16; Morris, *Edith Kermit Roosevelt*, 109–111.
43. Morris, *Edith Kermit Roosevelt*, 112; Hagedorn, *Roosevelt Family*, 17.
44. Hagedorn, *Roosevelt Family*, 138.
45. Ibid., 19, 21.
46. Morris, *Edith Kermit Roosevelt*, 140; Hagedorn, *Roosevelt Family*, 38.
47. Morris, *Edith Kermit Roosevelt*, 150; Hagedorn, *Roosevelt Family*, 29.
48. Morris, *Edith Kermit Roosevelt*, 157.
49. Wallace, *Historic Furnishings*, 8.
50. Ibid., 7; Hagedorn, *Roosevelt Family*, 58.
51. Hagedorn, *Roosevelt Family*, 60, 62.
52. Ibid., 67.
53. Morris, *Edith Kermit Roosevelt*, 186; Hagedorn, *Roosevelt Family*, 70, 72, 75.
54. Hagedorn, *Roosevelt Family*, 90, 92, 96.
55. Ibid., 101.
56. Hagedorn, *Roosevelt Family*, 38.
57. Ibid., 15; April 16, 1893 letter from Edith Kermit Roosevelt (EKR) to Emily Carow, Theodore Roosevelt Collection, Harvard University (TR-HU); Wallace, *Historic Furnishings*, 10.
58. Wallace, *Historic Furnishings*, 11–12, 15.
59. EKR to Emily Carow, August 27, 1901, TR-HU; Wallace, *Historic Furnishings*, 15.
60. EKR to Emily Carow, December 1, 1890, TR-HU; EKR to Anna Roosevelt Cowles, April 24, 1904, TR-HU; John G. Waite Associates, *Amendment to Existing Historic Structure*, 10–11; Wallace, *Historic Furnishings*, 17.
61. *Cultural Landscape*, Foreword, 19; *Historic Resource Study*, 99.
62. *Historic Structure Report*, 8; *Cultural Landscape*, 43, 45.
63. *Cultural Landscape*, 71–72.
64. Hagedorn and Roosevelt, *All in the Family*, 89–90.
65. Hagedorn, *Roosevelt Family*, 40, 153.
66. *Outlook*, October 25, 1913, 423–24, 430–34, 439–41.
67. Ibid.; Hagedorn, *Roosevelt Family*, 105; *Cultural Landscape*, Foreword, 19, 97.
68. Hagedorn and Roosevelt, *All in the Family*, 13–16.

69. Ibid., 88.

70. Hagedorn, *Roosevelt Family*, 33.

71. *Outlook*, October 25, 1913.

72. Hagedorn and Roosevelt, *All in the Family*, 13–16, 89–90.

73. *Cultural Landscape*, 23; Hagedorn and Roosevelt, *All in the Family*, 87–88; *Outlook*, October 25, 1913.

74. *Cultural Landscape*, 28; Hagedorn, *Roosevelt Family*, 33.

75. *Outlook*, October 25, 1913.

76. Hagedorn, *Roosevelt Family*, 109–10.

77. Ibid., 16; *Cultural Landscape*, 28.

78. Hagedorn, *Roosevelt Family*, 15; Lippert, "Early Life," 3–4.

79. Roosevelt, "Cross-Country Riding," 335.

80. Hagedorn, *Roosevelt Family*, 48, 83.

81. Ibid., 37.

82. *Historic Resource Study*, 76.

83. Hagedorn, *Roosevelt Family*, 41; Hagedorn and Roosevelt, *All in the Family*, 99.

84. Hagedorn and Roosevelt, *All in the Family*, 13–16.

85. Hagedorn, *Roosevelt Family*, 20.

86. Wallace, *Historic Furnishings*, 53.

87. Ibid., 16.

88. Hagedorn and Roosevelt, *All in the Family*, 22–23.

89. EKR to Emily Carow, October 7, 1899, TR-HU; Wallace, *Historic Furnishings*, 54.

90. Hagedorn, *Roosevelt Family*, 46; *Historic Resource Study*, 33, 48.

91. Roosevelt, *Autobiography*, 347.

92. Hagedorn and Roosevelt, *All in the Family*, 6.

93. *Historic Structure Report*, 19; Dewan, "White House."

Chapter 4

94. *Historic Resource Study*, 37; Hagedorn, *Roosevelt Family*, 134.

95. Hagedorn, *Roosevelt Family*, 139.

96. Wallace, *Historic Furnishings*, 24.

97. Somerville, "How Roosevelt Rests," 657.

98. Hagedorn, *Roosevelt Family*, 152–53.

99. Ibid., 176–79.

100. Ibid.

101. Ibid., 180; Dewan, "White House."

102. Hagedorn, *Roosevelt Family*, 190.

103. Wallace, *Historic Furnishings*, 19–21.

104. Ibid., 21.

105. *Historic Resource Study*, 48.

106. Hagedorn, *Roosevelt Family*, 161.

107. Ibid., 162; *Historic Resource Study*, 68, 70.

108. Hagedorn, *Roosevelt Family*, 236, 238.

109. Ibid., 207, 210–11.

110. Ibid., 213.

111. Wallace, *Historic Furnishings*, 23.

112. Hagedorn, *Roosevelt Family*, 245.

113. Ibid., 164–65.

114. Dewan, "White House"; Hagedorn, *Roosevelt Family*, 168–70.

115. *Historic Resource Study*, 39; Hagedorn, *Roosevelt Family*, 138, 181.

116. Bishop, *Theodore Roosevelt's Letters*, 59.

117. Hagedorn, *Roosevelt Family*, 215–18.

118. Ibid., 220–223, 226; Morris, *Edith Kermit Roosevelt*, 299.

119. Hagedorn, *Roosevelt Family*, 226–29.

120. Ibid., 229–30.

121. *Historic Resource Study*, 57.

122. Hagedorn, *Roosevelt Family*, 252.

123. Ibid., 172.

124. Needham, "Theodore Roosevelt as Country."

125. Somerville, "How Roosevelt Rests," 657.

126. Andrews, "Theodore Roosevelt as a Farmer"; *Historic Resource Study*, 97.

127. *Historic Structure Report*, 99; *Historic Resource Study*, 47; *New Barn*, 29; Morris, *Edith Kermit Roosevelt*, 299.

128. Hagedorn, *Roosevelt Family*, 232–34.

129. TR letter to Alice Roosevelt Longworth, July 21, 1905, TR-HU.

130. Hagedorn, *Roosevelt Family*, 232–36; Bleyer, "No Jail."

131. Hagedorn and Roosevelt, *All in the Family*, 9.

132. *Historic Structure Report*, 47.

133. Lee, *New Barn*, 19.

134. Ibid., 28, 30–31, 33.

135. *Cultural Landscape*, 28.

136. Ibid., 88–89.

137. Hagedorn, *Roosevelt Family*, 279.

Chapter 5

138. Ibid., 278.
139. Ibid., 281.
140. Wallace, *Historic Furnishings*, 25.
141. *Historic Resource Study*, 83.
142. Sagamore Hill account book, Sagamore Hill archives; Wallace, *Historic Furnishings*, 25.
143. Morris, *Edith Kermit Roosevelt*, 365; August 23, 1910 letter, Library of Congress (hereafter LC).
144. November 27, 1910 letter, TR Jr. Collection, LC.
145. Wallace, *Historic Furnishings*, 26.
146. Morris, *Edith Kermit Roosevelt*, 373; January 2, 1912 letter, TR Jr., LC.
147. Morris, *Edith Kermit Roosevelt*, 373; Hagedorn, *Roosevelt Family*, 303.
148. Wallace, *Historic Furnishings*, 28.
149. Butt, *Taft and Roosevelt*, 831–33.
150. *Historic Resource Study*, 112.
151. Ibid., 113; Lee, *Gray Cottage*, 27–28.
152. *Cultural Landscape*, 27; Lee, *Gray Cottage*, 4, 27.
153. Lee, *Gray Cottage*, 27–28.
154. Wallace, *Historic Furnishings*, 27.
155. *Historic Resource Study*, 112.
156. Ibid., 96; *Cultural Landscape*, 24.
157. *Outlook*, October 25, 1913.
158. *Historic Resource Study*, 100–1.
159. Hagedorn, *Roosevelt Family*, 309–10.
160. Ibid., 313–15.
161. Ibid., 321–22.
162. Ibid., 325–26.
163. Ibid., 328–29.
164. Ibid., 332–33.
165. Ibid., 335.
166. Morris, *Edith Kermit Roosevelt*, 407.
167. Hagedorn, *Roosevelt Family*, 365.
168. Dewan, "White House"; Morris, *Edith Kermit Roosevelt*, 412.
169. Morris, *Edith Kermit Roosevelt*, 413–15.
170. Account book, Sagamore Hill archives; KR-LC, June 16, 1918; EKR to Anna R. Cowles, February 1918, TR-HU; Hagedorn, *Roosevelt Family*, 392; Wallace, *Historic Furnishings*, 30.
171. KR-LC October 25, 1918.

172. Dewan, "White House"; Hagedorn, *Roosevelt Family*, 392–93.

173. Hagedorn, *Roosevelt Family*, 395; Dewan, "The White House."

174. Hagedorn, *Roosevelt Family*, 397; *Sagamore Hill*, 12–15; TR Day by Day.

175. Hagedorn, *Roosevelt Family*, 411–12; Morris, *Edith Kermit Roosevelt*, 423.

176. Hagedorn, *Roosevelt Family*, 411–12, 418.

177. KR-LC September 1, 1918; Wallace, Historic Furnishings, 29.

178. Morris, *Edith Kermit Roosevelt*, 428.

179. Ibid., 429.

180. Ibid., 431.

181. Ibid., 433; EKR to Ted, January 12, 1919, TR-LC.

182. Hagedorn, *Roosevelt Family*, 424. Although often cited from a letter in the Library of Congress, that letter does not contain the famous quote.

183. Letter to Kermit, January 12, 1919, TR-HU; Morris, *Edith Kermit Roosevelt*, 433.

184. Morris, *Edith Kermit Roosevelt*, 434.

185. Ibid., 436–37.

Chapter 6

186. Ibid., 441–42.

187. EKR to Kermit, March 30, 1919, KR-LC; EKR to Kermit, April 6, 1919, KR-LC.

188. Morris, *Edith Kermit Roosevelt*, 445.

189. Roth, *Roosevelt Memorial Association*, 11; Morris, *Edith Kermit Roosevelt*, 446.

190. Morris, *Edith Kermit Roosevelt*, 452; EKR to Ted, June 19, 1929, TR Jr., LC; Wallace, *Historic Furnishings*, 32.

191. "Homes of Famous Americans," *Better Homes and Gardens*.

192. EKR to Ted, June 28, 1935, TR Jr., LC; *Historic Furnishings*, 17.

193. Morris, *Edith Kermit Roosevelt*, 483–84.

194. EKR to Corinne R. Robinson, May 29, 1928, TR-HU; Morris, *Edith Kermit Roosevelt*, 463.

195. Morris, *Edith Kermit Roosevelt*, 467, 476.

196. Lee, *New Barn*, 37; *Cultural Landscape*, 107; *Historic Resource Study*, 100.

197. Lee, *Gray Cottage*, 31.

198. Morris, *Edith Kermit Roosevelt*, 489.

199. Ibid., 496; Lee, *Gray Cottage*, 5.

200. Lee, *New Barn*, 39; *Cultural Landscape*, 107, 112.

201. *Historic Structure Report*, 20; *Cultural Landscape*, 107.

202. Morris, *Edith Kermit Roosevelt*, 502.

203. Ibid., 506–7.
204. Ibid., 511.
205. Ibid., 513.
206. Ibid., 513.

Chapter 7

207. "Why Not Make National Monument," January 12, 1919, 5.
208. Roth, *Roosevelt Memorial Association*, 8–9.
209. Sagamore Hill archives.
210. Roosevelt Memorial Association annual report, 1947–1948, Sagamore Hill archives.
211. "The Theodore Roosevelt Association: A Brief History," 5–8.
212. Roth, *Roosevelt Memorial Association*, October 26, 1940, page vi, 13.
213. Ibid., December 23, 1947, March 16, 1948.
214. Ibid., vi, 40; Roosevelt Memorial Association annual report, 1948–1949; "Appraisal of the Art;" Bill of sale from Theodore Roosevelt trustees February 10, 1950.
215. "Sagamore Hill Home," *New York Herald Tribune*.
216. TR IV at house reopening, July 12, 2015.
217. "Agreement between Guarantee Trust," May 11, 1949; Roth, *Roosevelt Memorial Association*, vii, 28.
218. *Oyster Bay Guardian*, July 15, 1949; *Herald Tribune*, July 11, 1949; Roth, *Roosevelt Memorial Association*, 44, 46–47; transcript of Cove Neck hearing. July 20, 1949; "Cove Neck Blocks," *New York Times*, July 31, 1949.
219. Roth, *Roosevelt Memorial Association*, 52, 58, 75; New York State Legislative Record Index, 1951, 358, 1211.
220. Ronald F. Lee to Horace M. Albright, January 23, 1952; *Cultural Landscape*, 134, 153.
221. George A. Palmer to Herman Hagedorn, December 11, 1952.
222. Ibid.
223. Ibid.; Roth, *Roosevelt Memorial Association*, 87, 101–2.
224. Rogers Howell to Howard C. Smith, March, 28, 1949.
225. Roth, *Roosevelt Memorial Association*, 108–17.
226. *Historic Structure Report*, 20; Roth, *Roosevelt Memorial Association*, 108–17; *Cultural Landscape*, 139.
227. Wallace, *Historic Furnishings*, 34–35; Lee, *Gray Cottage*, 29–31.
228. "Theodore Roosevelt's Home," *New York Times*, June 15, 1953.

229. Wallace, *Historic Furnishings*, 36.
230. "Draft Finding Aid; "Sagamore Hill Expects," *Glen Cove Record-Pilot*, October 6, 1953; Oscar Straus to Ethel Derby, July 24, 1956; Straus to Jessica Kraft, October 17, 1956; Wallace, *Historic Furnishings*, 36; Straus to Kraft, October 17, 1956.
231. Memo from Leslie C. Stratton to Oscar Straus, November 28, 1960.
232. "U.S. May Acquire," *New York Times*, May 26, 1961.
233. *Cultural Landscape*, 134.
234. Memo from Straus to TRA trustees, July 26, 1961; "A Lifetime of Memories," *Long Island Press*, February 19, 1962; Trussell, "2 Theodore Roosevelt Shrines," *New York Times*, April 3, 1962; "Senate OKs Sagamore Hill," *Long Island Press*, July 19, 1962; Sagamore Hill archives.
235. Department of the Interior press releases, July 5, 1963, and July 9, 1963.

Chapter 8

236. *Administrative History*.
237. *Historic Structure Report*, 20; Wallace, *Historic Furnishings*, 37, 241; Lee, *Gray Cottage*, 9.
238. *Historic Structure Report*, 22, 47.
239. *Cultural Landscape*, 161.
240. Bleyer, "Light Idea at TR Home."
241. Wallace, *Historic Furnishings*, 35.
242. Bleyer, "Finishing Touches;" Ibid., "Sagamore Hill to Reopen."
243. Ibid., "TR's Garden to Bloom."
244. Ibid., "Plan Is Bully."
245. Ibid., "Reviving the Old Sagamore Hill."
246. Ibid., "Driving Back."
247. Ibid., "Bully! Grounds See Rebirth."
248. Ibid., "Bringing the Bloom."
249. Ibid., "Teddy on the Move."
250. Ibid., "'Friction and gravity.'"
251. Ibid., "AC Gets Cold Shoulder."
252. Ibid., "Window Opens."
253. Ibid., "Hung Up on History."

APPENDIX

254. Wallace, *Historic Furnishings*, 44, 60.

255. Ibid., 45; *Take a Look*, 5.

256. Wallace, *Historic Furnishings*, 46.

257. Ibid., 47; *Take a Look*, 9.

258. *Take a Look*, 15.

259. Ibid., 17.

260. Wallace, *Historic Furnishings*, 56.

261. Ibid., 51–52.

262. *Take a Look*, 19; Wallace, *Historic Furnishings*, 71.

263. Wallace, *Historic Furnishings*, 73; *Take a Look*, 21.

264. Wallace, *Historic Furnishings*, 69; *Take a Look*, 27.

265. *Take a Look*, 25.

266. Ibid., 23.

267. Wallace, *Historic Furnishings*, 62; *Take a Look*, 23; Jessica Kraft to Oscar Straus, October 17, 1956.

268. *Take a Look*, 31; Wallace, *Historic Furnishings*, 62.

269. *Take a Look*, 35.

270. Ibid., 33.

271. Wallace, *Historic Furnishings*, 93; *Take a Look*, 43.

272. *Take a Look*, 41; Wallace, *Historic Furnishings*, 62.

273. *Take a Look*, 37; Wallace, *Historic Furnishings*, 87.

274. *Take a Look*, 39.

275. *Cultural Landscape*, 37.

276. Lee, *New Barn*, 39.

277. *Cultural Landscape*, 27; Lee, *Gray Cottage*, 4, 27.

278. *Historic Resource Study*, 15–17; *Cultural Landscape*, 21; Wallace, *Historic Furnishings*, 37, 241.

Bibliography

Andrews, Walter E. "Theodore Roosevelt as a Farmer." *Farm Journal*, December 1906.

Bellavia, Regina M., and George W. Curry. *Cultural Landscape Report for Sagamore Hill National Historic Site*. Boston: U.S. Department of the Interior, National Park Service, Sagamore Hill National Historic Site, 2003.

Bishop, Joseph Bucklin, ed. *Theodore Roosevelt's Letters to His Children*. New York: Charles Scribner's Sons, 1919.

Bleyer, Bill. "AC Gets Cold Shoulder; Sagamore Hill Restoration Will Keep Historic Features, Including Ventilation." *Newsday*, August 14, 2013.

———. "Bringing the Blooms Back; Sagamore Hill Raising Money to Replant Cutting Garden." *Newsday*, January 17, 2012.

———. "Bully! Grounds See Rebirth; Sagamore Hill Being Transformed to Farm." *Newsday*, April 1, 2010.

———. "Driving Back Closer to History; The Brick Driveway at the Roosevelt Site Is Just One of Many Restoration Projects." *Newsday*, October 26, 2008.

———. "Fishing Touches for History's Sake." *Newsday*, April 6, 1990.

———. "'Friction and Gravity'; With Little More than Tape, He Protects the Historic before Renovations." *Newsday*, July 29, 2012.

———. "Hung Up on History. TR's Old Wallpaper Goes Back up as Sagamore Hill Redo Nears End." *Newsday*, November 7, 2014.

———. "Light Idea at TR Home; Rewiring Job Will Brighten Sagamore Hill." *Newsday*, November 17, 1988.

———. "Makeovers Aim to Restore Sagamore Hill to the Look, Feel of Theodore Roosevelt's Time." *Newsday*, April 25, 2011.

———. "No Jail for DeLand Man in Theft of T.R.'s Gun." *Newsday*, March 4, 2007.

———. "Plan Is Bully for TR Turf." *Newsday*, April 12, 2004.

———. "Reviving the Old Sagamore Hill; Park Service Hopes to Rip Up, Relocate the Museum's Parking Lot to Restore Roosevelt's Gardens, Pasture." *Newsday*, April 13, 2005.

———. "Sagamore Hill to Reopen after Face-Lift." *Newsday*, June 28, 1993.

———. "Still a Presence at Sagamore Hill." *Newsday*, April 5, 1998.

———. "Teddy on the Move: How the Sagamore Hill Team Will Protect More than 10,000 Items as TR's Home Is Renovated." *Newsday*, November 13, 2011.

———. "Tracing Roosevelt's Long Island Roots." *Newsday*, April 22, 1990.

———. "TR's Garden to Bloom Again; Sagamore Hill to Restore Agricultural Aspect of Historic Home." *Newsday*, August 7, 2002.

———. "A Window Opens into Past at Sagamore Hill." *Newsday*, November 12, 2013.

Brinton, Scott. "5 Towner Built T.R.'s Home on L.I." *Nassau Herald*, June 8, 1995.

Brooklyn Daily Eagle. "Why Not Make National Monument to Roosevelt at His Oyster Bay Home." January 12, 1919.

Butt, Archie. *Taft and Roosevelt: The Intimate Letters of Archie Butt—Military Aide.* Garden City, NY: Doubleday, Doran & Company Inc., 1930.

Carden, Marie L., with Richard C. Crissen. *Sagamore Hill: Home of Theodore Roosevelt; Historic Structure Report.* Washington, D.C.: U.S. Department of the Interior, National Park Service, Sagamore Hill National Historic Site, 1997.

Cowles, Anna Roosevelt, ed. *Letters from Theodore Roosevelt to Anna Roosevelt Cowles, 1870–1918.* New York and London: Charles Scribner's Sons, 1924.

DeWan, George. "The White House on the Hill." *Newsday*, April 5, 1998.

Draft Finding Aid for the Theodore Roosevelt Association (TRA) (1920–) Records Relating to Sagamore Hill, Addendum, 1894–1987. Washington, D.C.: U.S. Department of the Interior, National Park Service, Sagamore Hill National Historic Site, 2006.

"From the Senate." Congressional Record, August 3, 1961, and August 9, 1961.

Glen Cove Record-Pilot. "Sagamore Hill Expects to Reach 50,000 Mark in Attendance Shortly." October 6, 1953.

Hagedorn, Hermann. *The Roosevelt Family of Sagamore Hill.* New York: Macmillan Company, 1954.

Hagedorn, Hermann, and Theodore Roosevelt Jr. *All in the Family.* New York: G.P. Putnam & Sons, 1929.

Hart, Albert Bushnell, and Herbert Ronald Forleger, eds. *Theodore Roosevelt Cyclopedia.* New York: Roosevelt Memorial Association, 1941.

"Homes of Famous Americans." *Better Homes and Gardens*, October 1925.

John G. Waite Associates, Architects. *Amendment to Existing Historic Structure Report for Theodore Roosevelt Home*. New York: U.S. Department of the Interior, National Park Service, Sagamore Hill National Historic Site, 2010.

Lee, James J., III. *Gray Cottage Historic Structure Report*. New York: U.S. Department of the Interior, National Park Service, Sagamore Hill National Historic Site, 2009.

———. *The New Barn Historic Structure Report*. Washington, D.C.: U.S. Department of the Interior, National Park Service, Sagamore Hill National Historic Site, 2005.

Lippert, Mary Jane, ed. "The Early Life and Education of Miss Edna T. Layton." Oyster Bay Historical Society *Freeholder* 4 (Summer 1999): 3–4.

Long Island Press. "A Lifetime of Memories . . . An Intimate Visit with TR." February 19, 1962.

———. "Senate OKs Sagamore Hill Shrine." July 19, 1962.

McCullough, David. *Mornings on Horseback*. New York: Simon & Schuster, 1981.

Morison, Elting, ed. *The Letters of Theodore Roosevelt*. Vol. 1, *The Years of Preparation 1868–1898*. Cambridge, Massachusetts: Harvard University Press, 1951.

Morris, Sylvia Jukes. *Edith Kermit Roosevelt: Portrait of a First Lady*. New York: Coward, McCann & Geoghegan, 1980.

Needham, Henry Beach. "Theodore Roosevelt as a Country Gentleman." *Country Calendar*, October 1905.

New York Herald Tribune. "Sagamore Hill Home Acquired as Theodore Roosevelt Shrine." February 9, 1950.

———. "Shrine to Theodore Roosevelt Opposed by Cove Neck Villagers." July 22, 1949.

New York Times. "Cove Neck Blocks Roosevelt Shrine." July 31, 1949.

————. "President to Seek 3 Shrines in State." February 9, 1962.

————."Roosevelt Estate Valued at $981,171." January 26, 1923.

————. "Theodore Roosevelt's Home Made Shrine by Eisenhower." June 15, 1953.

————. "U.S. May Acquire Sagamore Hill." May 26, 1961.

Newsday. "Udall Wants TR's LI Home as U.S. Park." May 26, 1961.

Oyster Bay Pilot. "President Roosevelt at Home." June 20, 1903.

Roosevelt, Theodore. "Cross-Country Riding in America: Riding to Hounds on Long Island." *Century Magazine*, July 1886.

————. Letter to Henry H. Saylor, editor of *Country Life in America*, October 3, 1915. Houghton Library, Harvard University.

————. "Outdoors and Indoors." *Outlook*, October 25, 1913.

————. *Theodore Roosevelt: An Autobiography*. New York: Macmillan Company, 1913.

Sagamore Hill. Washington, D.C.: U.S. Department of the Interior, National Park Service, Sagamore Hill National Historic Site, 1978.

Sagamore Hill National Historic Site Administrative History. Washington, D.C.: U.S. Department of the Interior, National Park Service, Sagamore Hill National Historic Site, 2007.

Sagamore Hill National Historic Site, General Management Plan. Washington, D.C.: U.S. Department of the Interior, National Park Service, Sagamore Hill National Historic Site, 2008.

Somerville, Charles. "How Roosevelt Rests at Oyster Bay." *Broadway*, September 1907.

Take a Look Inside Theodore Roosevelt's Sagamore Hill. Fort Washington, PA: Eastern National, 2015.

Theodore Roosevelt and His Sagamore Hill Home Historic Resource Study. Washington, D.C.: U.S. Department of the Interior, National Park Service, Sagamore Hill National Historic Site, 2007.

Trussell, C.P. "2 Theodore Roosevelt Shrines in New York Backed by House." *New York Times*, April 3, 1962.

Wallace, David H. *Historic Furnishings Report Volume 1: Historical Data.* Washington, D.C.: U.S. Department of the Interior, National Park Service, Harpers Ferry Center. Sagamore Hill, 1989.

Wilshin, Francis. *Historic Resource Study: Sagamore Hill Historical Base Map Documentation.* Washington, D.C.: U.S. Department of the Interior, National Park Service, Denver Service Center, October 1972.

FROM THE ARCHIVES AT SAGAMORE HILL NATIONAL HISTORIC SITE

Agreement between Guarantee Trust Company of New York and Surviving Trustees of Theodore Roosevelt Estate Conveying Sagamore Hill to the Roosevelt Memorial Association. May 11, 1949.

Appraisal of Property Situated at Cove Neck . . . Estate of Theodore Roosevelt Sr. Prepared for the Roosevelt Memorial Association, April 3, 1948.

Appraisal of the Art and Other Personal Property of the Estate of Theodore Roosevelt, Sagamore Hill, Oyster Bay, Long Island, N.Y. Prepared by Parke-Bernet Galleries Inc., New York, September 20, 1948.

Bill of Sale from Theodore Roosevelt Estate Trustees and Heirs to the Roosevelt Memorial Association for Contents of Sagamore Hill. February 10, 1950.

Minutes of the Board of Trustees, Incorporated Village of Cove Neck, New York, February 12, 1951.

National Register of Historic Places Nomination Form for Sagamore Hill Submitted by Bronwyn Krog, October 2, 1978.

Petition in the Matter of Acquiring Title by the County of Nassau in Fee Together with Temporary Working Easements for the Layout of the Sagamore Hill Road, etc., Clerk's No. 2708 (Year 1953), Office of the County Clerk (Nassau County), Mineola, NY.

Proceedings of the Board of Supervisors, Nassau County, New York, March 23, 1953, 444–45, 650–51, and July 13, 1953, 1062–63.

Roth, Gary G. "The Roosevelt Memorial Association and the Preservation of Sagamore Hill, 1919–1953." Master's thesis, Wake Forest University, Winston-Salem, NC, 1980.

TR Day by Day Chronology, manuscript.

FROM THE ROOSEVELT MEMORIAL ASSOCIATION/ THEODORE ROOSEVELT ASSOCIATION ARCHIVES AT SAGAMORE HILL NATIONAL HISTORIC SITE

Albright, Horace M. Letter to Hermann Hagedorn, September 11, 1952.

Chadbourne, William, and William E. Delahanty. "Outline of Proposed Work at Sagamore Hill, Cove Neck, Long Island." February 27, 1951.

Delahanty, William E. Letter to Howard C. Smith, May 29, 1951.

Guibert, John C. Letter to Harry Tappen, December 17, 1951.

Howell, Rogers. Letter to Howard C. Smith, March, 28, 1949.

Lignell, Jack W. Letter to William Chadbourne, August 23, 1950.

New York State Legislative Record Index. Albany, NY: Legislative Index Company, 1951. 358, 1211.

Roosevelt Memorial Association Annual Reports, 1947–1948, 1948–1949.

Roosevelt Memorial Association. Board of Trustees minutes, October 26, 1940.

Roosevelt Memorial Association. Executive Committee minutes, December 23, 1947; March 16, 1948; November 29, 1949; February 7, 1950; April 19, 1950; January 2, 1951; May 29, 1951; October 2, 1951; October 27, 1951.

Roosevelt Permanent Memorial National Committee minutes, March 24, 1919.

Smith, Howard C. Letter to Hermann Hagedorn, December 1, 1948.

———. Letters to Frank R. McCoy, November 15, 1949, and December 6, 1949.

———. Letters to Roger W. Straus, July 2, 1951, and December 27, 1951.

———. Memos, May 12, 1948, and December 13, 1948.

"The Theodore Roosevelt Association: A Brief History." *Theodore Roosevelt Association Newsletter*, August 1974, 1951, and June 14, 1951.

Transcript of Cove Neck Village Board Hearing July 20, 1949.

MISCELLANEOUS

Author interview with historians John Hammond and Liz Roosevelt, 2015.

Remarks by Tweed Roosevelt and Theodore Roosevelt IV at Sagamore Hill, July 12, 2015.

Theodore Roosevelt, Edith Kermit Roosevelt, and Kermit Roosevelt and Belle Roosevelt Papers, Manuscript Division, Library of Congress, Washington, D.C.

Theodore Roosevelt and Edith Kermit Roosevelt Papers, Houghton Library, Harvard University.

Index

About the Author

B ill Bleyer was a prize-winning staff writer for *Newsday*, the Long Island daily newspaper, for thirty-three years before retiring in 2014 to write books and freelance for magazines and *Newsday*. He is coauthor of *Long Island and the Civil War: Queens, Nassau and Suffolk Counties During the War Between the States*, published in 2015 by The History Press. He contributed a chapter to the anthology *Harbor Voices: New York Harbor Tugs, Ferries, People, Places & More*, published in 2008. And he was a contributor and editor of *Bayville*, a history of the Long Island village released by Arcadia Publishing in 2009.

The Long Island native has written extensively about history for newspapers and magazines. In 1999–2000, he was one of four *Newsday* staff writers assigned full time to "Long Island: Our Story," a yearlong daily history of Long Island that resulted in three books and filled hundreds of pages in the newspaper.

His work has been published in *Civil War News*, *Naval History*, *Sea History*, *Lighthouse Digest* and numerous other magazines and in the *New York Times*, *Chicago Sun-Times*, the *Toronto Star* and other newspapers.

Prior to joining *Newsday*, Bleyer worked for six years at the *Courier-News* in Bridgewater, New Jersey, as an editor and reporter. He began his career as editor of the *Oyster Bay Guardian* for a year.

Bleyer graduated Phi Beta Kappa with highest honors in economics from Hofstra University, where he has been an adjunct professor of journalism and economics. He earned a master's degree in urban studies at Queens College of the City University of New York.